HEALTH
HAZARDS
MANUAL
FOR
ARTISTS

HEALTH HAZARDS MANUAL FOR ARTISTS

MICHAEL McCANN, PH.D., C.I.H.

Fourth Revised and Augmented Edition

LYONS & BURFORD PUBLISHERS

Printed in the United States of America

Design by Catherine Lau Hunt

10 9 8 7 6 5 4 3 2 1

Library of Congress Cataloging-in-Publication Data

McCann, Michael, 1943–
 Health Hazards manual for artists.
 Bibliography: p.
 Includes index.
 1. Artists—Health and hygiene—Handbooks, manuals, etc.
2. Artisans—Health and hygiene—Handbooks, manuals, etc.
I. Title.
RC963.6.A78M324 1985 700′.28′9 85-13371
ISBN 0-941130-06-1

CONTENTS

PART THREE *Safety in the Studio*

APPENDICES

PREFACE TO FOURTH EDITION

The success of the third edition of *Health Hazards Manual for Artists,* which sold over 8,000 copies, brings the total number of copies sold since its first publishing in 1975 to over 53,000 copies. This fourth edition of *Health Hazards Manual for Artists* is basically an updating of information to keep it current with present knowledge and changes in labeling laws. The major change in the book is the expansion of Chapter 20, **Know Your Materials,** to give more information on labels and Material Safety Data Sheets. In addition the fire hazards section and bibliography have been redone. Hopefully, this edition will be as popular as the previous editions.

MICHAEL MCCANN, PH.D., C.I.H.
May 1994

PREFACE TO FIRST EDITION

Artists and craftspeople, like other workers, have a right to work in a safe environment. It is apparent, however, that many of the materials used by artists and craftspeople are hazardous and present a threat to their health. The New York Chapter of the National Art Workers Community therefore resolves that:

1. Art schools have a responsibility to set an example of how to work safely with art materials. Art schools should provide safe working conditions and should include as an integral part of their curriculum information on how to work with them safely.

2. Artists and craftspeople have the right to know the hazards of the materials with which they are working. Therefore, art suppliers should fully label their art materials both as to composition and hazards. In addition, art suppliers should undertake research to develop the safest art materials possible.

3. Art supply stores should support full-disclosure labeling of art materials and should pressure art suppliers to conform with this standard.

4. Municipal, state, and federal governments should pass adequate legislation of full-disclosure labeling of art materials and any other legislation needed to protect the right to work in a safe environment.

5. Government agencies should sponsor research to investigate the occupational health problems of artists and craftspeople and should provide free medical treatment where necessary.

The preceding resolution, passed by NAWC and endorsed by the Foundation for the Community of Artists, resulted from the concern generated by a series of articles, "Health Hazards in Art," which I wrote for *Artworkers News.* These articles created a flood of letters from artists describing their own experiences and asking for more information. It soon became clear that there were two basic problems: the question of adequate labeling of art materials as to their hazards, and the question of the dissemination of information

about the hazards of art materials and how to work with them safely.

The question of labeling is crucial because if you don't know what is in a particular material, there is no way to know the potential hazard of working with it. I believe that full-disclosure labeling is necessary. This means that all the contents of art materials should be listed on the label, along with their hazards and necessary precautions. In order to achieve this, art organizations and artists will have to put pressure on art suppliers, and on those government agencies like the Consumer Products Safety Commission whose responsibility it is to make certain that materials are properly labeled.

The other main problem is that of education. Information on the health hazards of art materials and how to work with them safely should be widely disseminated throughout the art education system. Art students at every level should receive this information at the same time they learn the various art techniques so that it becomes part of their work habits. In order to make the information in the *Artworkers News* articles available to a larger audience, the Foundation for the Community of Artists decided to reprint the entire series in the present book form. I have updated the information where needed and added an index to make the book more useful as a reference.

How can the information in this book best be used? The purpose of the articles and the present book is to give the working artists or craftsperson a good idea of the hazards of the materials he or she is using, and suggestions on how to work with them safely. In many cases it is not known whether a particular material will cause health problems to an artist using it. Since very little research has been done on the medical problems of artists and their materials, I have had to go by whether the material has created problems among industrial workers. In some cases, industrial workers have a greater exposure to these materials than artists and would, therefore, be expected to have greater problems. However, in many cases, I have found that artists are working with toxic materials under much more hazardous conditions than are commonly found in industry, usually because of the complete lack of safety precautions on the part of the artists. Therefore, I believe that industrial experience is a good guideline to determine whether material might be hazardous for artists, at least until medical studies prove otherwise.

A major factor in determining the degree of hazard in using toxic materials is the susceptibility of the artists using the material. A person's susceptibility to a particular material depends upon a variety of factors, including age, state of health, the environment, and the target organ of the material. These various factors can be used to define high-risk groups.

Children are a particularly high-risk group because of their size (an amount of toxic materials that would not affect an adult can harm a child), and because of the immaturity of their body tissues. Small children and infants are particularly susceptible to lung problems because of their small air passageways and lungs. Therefore, extreme care should be taken not to expose children to toxic art materials, whether in a home studio or in art classes for children.

Other high-risk groups include people with allergies, smokers, excessive drinkers, older people, and people with disease-weakened or damaged organs (particularly the heart, lungs, and liver). In addition, such environmental factors as excessive air pollution and exposure to other chemicals can significantly affect a person's susceptibility to health problems created by exposure to art materials.

Finally, I want to discuss how to tell if you are poisoning yourself with your art materials. If you find that you are experiencing new or unusual symptoms during or after work, then you might be work-
ing unsafely with your materials. These symptoms can include headaches, dizziness, fatigue, blurred vision, nausea, nervousness, chronic coughing, loss of appetite, skin problems, irritability, breathing difficulties, and similar problems. If these symptoms persist, you should see a doctor. When doing so, take along a list of all the materials with which you are working so that the doctor can determine whether the materials might be the cause of your symptoms. If you are working with highly toxic materials like lead, barium, toxic solvents, silica dust, and the like, then you should have regular checkups to make sure they are not affecting your health. In any case, remember that art materials, like many other chemicals, may be hazardous to your health and should be handled accordingly.

MICHAEL McCANN, PH.D.
July 1975

part

ONE

▲

HOW
ART
MATERIALS
AFFECT
YOU

1

▲

WHAT IS THE PROBLEM?

Are many art materials hazardous? In 1974, when I first began writing and lecturing about the health hazards of art and craft materials, people found it hard to believe. Convincing people—including artists, school and college officials, and the health professions—that there *is* a problem was the first and hardest step. The first edition of *Health Hazards Manual for Artists* was a major factor in promoting the awareness of this problem.

My original concern was based on the fact that artists were using the same chemicals as industry. And it was known that industrial workers were developing occupational diseases from exposure to these chemicals. The problem was that artists were using these chemicals, often at home, without adequate precautions and usually without even knowing that these chemicals were dangerous. Thus there was concern that artists could develop the same occupational diseases as workers in industry.

And that concern has been shown to be valid. Innumerable case studies have shown that artists can develop dermatitis, lead poisoning, silicosis, liver and kidney damage, nerve damage, reproductive problems, carbon monoxide poisoning, cancer, and similar ailments—all occupational diseases caused by chemical exposure. Industrial hygiene studies involving air sampling have shown, in many instances, that artists can be exposed to hazardous chemicals at concentrations above legal standards.

In 1981 the National Cancer Institute conducted a study of the causes of deaths of artists. This study involved 1,598 artists whose obituaries were published in *Who's Who in American Art* between 1940 and 1969. Death certificates were obtained for 1,253 men and 345 women artists, and their causes of death were

3

compared to the causes of death for all United States men and women. This proportionate mortality study, as it is called, found that male artists had a statistically significant greater number of deaths from heart disease, leukemia, and cancers of the brain, kidney, bladder, colon, and rectum. The study also found that the leukemia and bladder cancers were more frequent among painters than sculptors and other artists.

For women artists, the statistically significant increased rates of death were from rectal cancer, breast cancer, and lung cancer. Since there were fewer women than men in the study group, it was harder to find statistically significant results.

This type of epidemiological study does not prove that art materials caused these excess deaths, but simply says there is a statistical relationship between being an artist and developing these diseases. However, workers in industry using the same chemicals that artists use also have excess rates of these same types of cancers.

Now that it has been more generally accepted that art materials can cause occupational diseases among artists, the problem becomes what can be done about it.

The problem of art hazards has several aspects to it, including the presence of extremely toxic chemicals in many art materials, inadequate labeling of art materials, the lack of adequate training of students about art hazards in the schools, and improper diagnosis of illnesses caused by exposure to toxic art materials.

Many art materials still contain very hazardous chemicals that are often unnecessary because adequate substitutes are available. The classic example is flake white in oil paints. A few painters say it is a necessary pigment but most painters have long ago replaced it with zinc white or titanium white. Other examples of chemicals that should be eliminated include cadmium in low melting silver solders for jewelry, asbestos in talcs and clays or as insulation, and lead compounds (including lead frits) and radioactive uranium oxide in pottery glazes and copper enamels. Cadmium fumes, asbestos, and uranium oxide all have been shown to cause lung cancer, and lead compounds are well known, as a cause of nerve damage, kidney damage, and reproductive system damage.

Some progress has been made in this area. The Nuclear Regulatory Commission banned uranium compounds in enamels in 1984. Recently, several art-material manufacturers have come out with lines of lead-free pottery glazes and enamels. Asbestos is still a

major problem in talcs and clays, but some companies are experimenting with talc-free clays and there are some asbestos-free talcs available. Benzene, which can cause leukemia, was eliminated from art materials such as paint strippers in 1978.

There has been a lot of progress in the area of the labeling of art materials. The problem was that, prior to 1988, the Federal Hazardous Substances Act only required labeling of chemicals that are immediately or acutely toxic. Warnings about the long-term or chronic hazards of art materials had not been mandatory and almost no manufacturer listed chronic hazards. As the result of publicity about the hazards of art materials, and testimony at Congressional and various state legislative hearings on art hazards, the question of chronic hazard labeling became a major concern during the 1980's.

In the early 1980's, a voluntary labeling standard (ASTM D-4236) requiring warning labels about chronic hazards of art materials was developed under the auspices of the American Society for Testing and Materials (ASTM). This voluntary standard was developed by representatives from industry, artists' organizations, toxicologists and other interested parties, including this author. Starting in 1985, art materials with chronic hazard labeling certified by the Arts and Crafts Materials Institute, an industry trade association, began to appear on the market.

The problem with the voluntary standard approach is that it allowed each manufacturer to decide whether it wanted to put a chronic hazard warning label on its products. Many of the larger manufacturers of fine art materials did so, but most crafts manufacturers and small manufacturers did not put chronic hazard warning labels on their art materials.

I favored the mandatory labeling of the chronic hazards of art materials, as did many others. It should not be up to the manufacturer to decide whether it wants to put warning labels on its products. During the mid 1980's, laws requiring chronic hazard labeling of art and craft materials and banning toxic chemicals in children's art materials were passed in California, Florida, Illinois, Oregon, Tennessee, and Virginia.

At the same time, lobbying went on in Washington by many artists' organizations and the U.S. Public Interest Research Group in support of a national labeling law. This was even supported by many manufacturers and their trade associations since they did not

like different labeling requirements in different states, nor the fact that companies not putting warning labels on their products had a competitive advantage. As a result, in 1988 Congress passed the Labeling of Hazardous Art Materials Act. This law amended the Federal Hazardous Substances Act to make ASTM D-4236 into law, and required the Consumer Product Safety Commission to define what is a chronic hazard. The law also allowed the Consumer Product Safety Commission to obtain court injunctions against any school that purchased chronically toxic art supplies for use in elementary school.

One of the major problem areas is still the schools where art is taught. We have found hazardous art materials being used without suitable precautions at every level from preschool through elementary and secondary schools to colleges. A reason for this is that many teachers still do not know about the hazards of art materials they use or how to work safely. In addition, school administrators often do not pay attention to teachers' requests for proper ventilation or proper protective equipment. This has resulted in lawsuits by injured students against both teachers and schools.

This is not to say that all teachers and schools are not addressing the problem of art hazards. Many art schools, school districts, and teachers' organizations have had speakers from the Center for Safety in the Arts to educate them about art hazards. In addition, we have done many inspections of art schools and school districts at their request to ascertain hazards and make recommendations for their correction.

Teaching about the hazards of art materials and how to work safely should occur when students first learn art techniques. If included in the art and art-education curriculums in our schools, this would ensure that the next generation of artists knows about the hazards of their materials and how to work safely with them.

The present generation of artists, however, also needs to be informed about art hazards. We have tried to accomplish this by giving lectures and workshops for artists' organizations and by publishing a large amount of information on art hazards. In addition, the Art Hazards Information Center, which is a project of the Center for Safety in the Arts, answers about fifty written and telephoned inquiries daily on art hazards.

Artists do get ill from overexposure to hazardous art mate-

rials and it is essential that they can obtain a proper diagnosis of their illness. Unfortunately, most physicians do not have any training in the toxic effects of chemicals and cannot properly diagnose such an illness. In fact, I have seen instances where illnesses diagnosed as psychosomatic have been identified as lead poisoning once the artist went to a physician with training in occupational medicine. If in doubt, you should not hesitate to go to a physician with the needed expertise. Today, there are dozens of occupational health clinics around the country with expertise in the toxic effects of chemicals found in art materials. (See Appendix 1.)

2

▲

RISK FACTORS

Just how hazardous to health are art materials? The actual risk involved depends on several factors, most importantly length, frequency, and amount of exposure, the toxicity of the material, total body burden, effects of exposure to multiple chemicals, and personal susceptibility. In addition, of course, a chemical has to enter the body to cause injury.

CONDITIONS OF EXPOSURE

How much material you are exposed to, for how long, and how often, are crucial factors determining the total potential exposure to a chemical.

For example, an artist who is exposed only to a cup of a toxic solvent for a few minutes a day is much less likely to develop problems than an artist who might use several pints of the same solvent over a period of some hours. Similarly, exposure to toxic materials once a week or month is much less hazardous than daily exposure.

In some instances, an artist working long hours preparing for a show or at the end of the school term could have greater exposure than a worker in industry using the same chemical eight hours a day. For example, the Threshold Limit Values used in industry to determine supposed safe levels of exposure to a chemical are based on an eight-hour work day. This means that there are eight hours of exposure to the chemical, and then the body has sixteen hours without exposure to detoxify and excrete the chemical. If, however, you are working twelve or more hours a day, then you have twelve hours of exposure to the chemical instead of eight

hours, and your body has only twelve hours instead of sixteen hours to get rid of the chemical.

TOXICITY

The toxicity of a chemical is defined as its ability to cause body damage. The more toxic the chemical, the less it takes to injure you. For example, small amounts of lead white pigment can cause poisoning if ingested, whereas the body can tolerate much larger amounts of iron oxide pigments without ill effects. Lead therefore has a higher toxicity than iron. Whenever possible, you should choose the least toxic art material in order to minimize the chances of injury.

TOTAL BODY BURDEN

The total body burden of a chemical is the total amount of that chemical in the body from all possible sources. For example, if you are doing stained glass, you might get a body burden of lead from exposure to lead fumes from the solder, lead dust from the came, and possibly lead pigments.

However, this does not define your total body burden of lead. There are many other possible sources of lead in the environment that could also contribute to your total body burden of lead. These include lead from gasoline exhaust, from drinking water that comes through lead pipes, from any nearby smelters, and from lead in food or drinks that resulted from the dissolving of lead in the solders of tin cans or from pottery glazes on cups and other food and drink containers. All of these sources can contribute to the total amount of lead in your body.

MULTIPLE EXPOSURES TO CHEMICALS

Exposure to many different chemicals can also increase the risk and extent of injury to a particular organ. For example, damage to the lungs resulting from excess exposure to etching gases can be intensified by simultaneous exposure to carbon arc gases, solvent vapors, cigarette smoke, air pollution, and the like. In some cases, this effect is not a simple additive effect but can be a multiplicative or synergistic effect. An example is smoking and asbestos exposure. Smokers have a tenfold increased risk of lung cancer compared to nonsmokers. Nonsmokers who work with asbestos have about a

fivefold excess risk of lung cancer. Smokers who work with as-bestos, however, can have about a fifty- to ninety-fold excess risk of lung cancer.

Similarly, exposure to many chlorinated solvents (e.g. car-bon tetrachloride or trichloroethylene) and alcoholic beverages can have a serious and possibly even fatal synergistic effect.

The major problem is that it is impossible to test all the com-binations of chemicals to which we are exposed to determine these possible synergistic effects. This becomes an important reason to minimize exposure to all chemicals to the greatest extent possible.

PERSONAL SUSCEPTIBILITY

If two people are in the same studio and have the same exposure to toxic chemicals, one might get ill and the other might not. Why? The reason is the individual susceptibility of people and the exis-tence of *high-risk groups.*

One of the highest-risk groups is children because of their low body weight and several other reasons. The problems of chil-dren and art materials will be discussed further in Chapter 19. Other high-risk groups include smokers, heavy drinkers, asthma-tics, people with chronic heart, liver, lung or other problems, pregnant women, and the elderly.

People with a variety of disabilities are also at higher risk. For example, solvents could induce epileptic seizures in susceptible people, and noise in woodshops could further damage the residual hearing of people with severe hearing impairments.

ROUTES OF ENTRY INTO THE BODY

There are three common ways in which toxic substances can enter the body: (1) by skin contact, (2) through inhalation, and (3) through ingestion.

Skin contact is the most frequent way in which materials enter the body. Our skin has a defensive barrier consisting of an outer waxy coating and a layer of dead cells intertwined with a tough protein called keratin. Normally this barrier protects the skin against chemicals and physical injury. However, many substances—such as acids, caustic alkalis, organic solvents, peroxides, bleaches,—can destroy this protective coating and attack the skin layers underneath, causing various types of skin ailments.

Some chemicals—phenol (carbolic acid), turpentine, benzene, toluene, and methyl alcohol, for example—can even penetrate farther and enter the bloodstream to travel to other parts of the body. By stripping away the protective waxy skin coating, many organic solvents make it possible for other chemicals to penetrate the skin's barrier. Obviously, the way to prevent these hazardous substances from entering the body through the skin is to ensure that the chemicals never come in contact with the skin.

The second and most common way for substances to enter the body is through breathing in their vapors, spray mists, gases, fumes, smoke, and dusts. Some substances—for example, glacial acetic acid (a "stop bath" in photography), sulfur dioxide gas from kilns, welding fumes, and noxious gases resulting from overheating of many plastics—can immediately damage the sensitive linings of the airways and lungs. Others, especially dusts, can cause chronic diseases. One of the important factors here is the size of the particles. Finer particles enter deeper into the lungs. Large particles can get trapped by the mucus of the nose and upper respiratory passages, where they can be swallowed or spit up.

Whether or not a substance get beyond the lungs to affect the rest of the body depends on how soluble it is in the blood.

The third method of exposure is through ingestion. This occurs more often than many people realize through mouth contact with contaminated hands, food, and cigarettes. This can especially be a problem for artists whose studios are in their living quarters. The habit of pointing paintbrushes with the lips can be particularly dangerous. Another source of ingestion is inhaled dusts that are carried up into the throat by lung-clearance mechanisms, and then swallowed. Once in the stomach, the body's defenses act to absorb the harmful materials into the bloodstream slowly, and in small amounts. However, this is often not sufficient to prevent poisoning.

EFFECTS OF ART MATERIALS

ON THE BODY

Now that we have seen how dangerous art materials enter the body, let us look at how the materials can damage the body. One of the first things we have to know is the difference between acute and chronic illness. An acute illness is one that occurs as a result of a single, often large, exposure and that occurs within a short period after the exposure. Examples are burns from exposure to concentrated acids, and chemical pneumonia from overexposure to cadmium fumes from silver soldering. A chronic illness is one that occurs after exposure over a period of months, years, or even decades, often from low levels of exposure. Chronic illnesses can occur in two ways: from buildup of a chemical in the body, as in chronic lead poisoning; or from an accumulation of damage to the body from repeated exposures to the chemical. In the latter case, the chemical does not accumulate in the body; only the damage it does builds up. Examples of the latter are nerve damage from exposure to certain solvents, cancer, and chronic bronchitis.

THE SKIN

As mentioned earlier, many materials can harm the skin directly. In fact, skin ailments are the most frequent kind of occupational hazard caused by chemical substances. Most artists whom I have talked to have had at some time or another a rash, burn, or other skin problem caused by working with art materials.

Skin diseases caused by chemicals are mostly of two types: direct irritation and allergies.

Chemicals that cause direct irritation (irritant dermatitis) are called irritants, and affect everyone who comes in sufficient contact with them. The types of damage that can appear include reddening, itching, blistering, thickening, hardening, and flaking of the skin. In some cases, it takes a long time and repeated exposure to show damage. The condition lasts as long as exposure continues and usually disappears after contact is ended. Irritants commonly encountered by artists include acids, alkalis, organic solvents (xylene, toluene, and other aromatic solvents, chlorinated hydrocarbons, turpentine, petroleum solvents, ketones) and such others as chromium compounds, arsenic compounds, and fiberglass.

Besides irritants that affect everybody, many substances are sensitizers and cause allergies. Sensitizers affect only some people, although some are so strong they will affect most people. Allergies don't occur at the first exposure. Often a person can work with a material for years before developing a sensitivity to it. After that, however, the sensitivity never disappears and even very small amounts of the material can bring on the allergic reaction.

Some common sensitizers that affect many people include many plastics materials (in particular, epoxy resins and amine hardeners), chromate and bichromate salts, nickel and cobalt compounds, formaldehyde, turpentine, and many tropical woods.

Skin cancer is another type of skin disease that is of concern. The major problem is that we don't know whether many common chemicals cause cancer or not because cancers usually take twenty to forty years to develop. Some substances—including arsenic compounds and lampblack—have been definitely shown to cause skin cancer. The major cause of skin cancer, however, is ultraviolet light. This is why people who work outdoors or who spend lots of time in the sun have high rates of skin cancer. Sources of ultraviolet radiation to which artists can be exposed include carbon arcs and arc welding.

The eyes are even more sensitive than the skin to damage. Examples of eye problems are damage to the cornea from ultraviolet radiation, cataracts from infrared radiation, and conjunctivitis and other eye diseases from exposure to acids, ammonia and other alkalis, peroxide hardeners, and other irritants.

RESPIRATORY SYSTEM

Acute respiratory diseases result when strongly irritating substances (such as ammonia, nitric acid etching gases, glacial acetic acid, ozone from welding) burn the tissues of the lungs or upper respiratory system. If the chemical dissolves in the fluids in the upper respiratory system, then acute bronchitis can result. Examples include overexposure to sulfur dioxide from kilns and to glacial acetic acid. If the chemical reaches the air sacs at the bottom of the lungs, then chemical pneumonia (pulmonary edema) can result. This can occur from overexposure to nitrogen dioxide from acid etching, ozone from arc welding, and cadmium fumes from silver soldering. This can be fatal. In addition, bacterial pneumonia is often a complication of this disease. Hypersensitivity pneumonia is an acute disease caused by exposure to redwood dust, ivory dust, mother-of-pearl, moldy cotton, and some feathers. Metal fume fever, a flu-like disease, can result from over-exposure to zinc and copper fumes, in particular, from welding and foundry operations.

Chronic lung diseases, such as chronic bronchitis and emphysema, can result from repeated exposures over several years to low levels of irritating substances. This results in damage to the larger airways that lead to the air sacs. Over the years, these chronic diseases can be progressive and result in more and more coughing and mucus production and an increased susceptibility to respiratory infections. Smoking is the major cause of these diseases, but they can also be caused by exposure to many irritants including nitrogen dioxide, ozone, sulfur dioxide, acid soldering fluxes, and others.

Another major form of lung disease is pulmonary fibrosis (e.g. silicosis), a permanent scarring of the lung tissue. This can result from continual exposure to certain dusts, such as asbestos, silica from clays and many stones, beryllium, and redwood sawdust. This disease is similar to miners' black lung.

Many materials including Western Red Cedar and many tropical woods, formaldehyde, fiber-reactive (cold water) dyes, isocyanates (found in polyurethane resins), epoxy hardeners, turpentine, nickel compounds, and rosin core solder fumes can cause asthma or other respiratory allergies.

Respiratory cancer can be caused by exposure to lead and zinc chromate (chrome yellow and zinc yellow), asbestos, arsenic, cadmium, nickel, uranium oxide, and of course smoking. Hard-

wood dust may cause nasal and nasal sinus cancer; formaldehyde causes nasal cancer in animals.

HEART AND CIRCULATORY SYSTEM

If the lungs are severely damaged, this puts an enormous strain on the heart as it then has to pump more blood to try to get enough oxygen for the body. In fact, heart failure is a major cause of death for people with chronic bronchitis, emphysema, and pulmonary fibrosis.

However, the heart is also directly susceptible to many chemicals. Barium compounds, cobalt compounds, and several solvents—for example, methylene chloride, methyl chloroform, freons, and toluene—can cause heart damage, the latter by inducing changes in heart rhythms (arrhythmias) at high levels.

The heart is also susceptible to damage from chemicals that interfere with the transport of oxygen through the blood. The actual oxygen-carrying molecule in red blood cells is hemoglobin. Chemicals like carbon monoxide, some dyes, methylene chloride, and photographic developers can affect the hemoglobin so that it can no longer carry oxygen, leading to oxygen starvation and possibly death.

Chemicals that affect the formation of red and white blood cells and platelets can cause very serious illness. Benzene (benzol), for example, destroys the bone marrow so it no longer produces these cells. This results in aplastic anemia and possibly leukemia. Other substances that can cause anemia include lead, cadmium, and many glycol ethers.

LIVER

One of the liver's main functions is to detoxify substances, both those that enter the body from outside and those that the body produces. However, it has a limited capacity to do this and liver damage can result when this capacity is exceeded. Further, when the liver is damaged it can't detoxify the body's own toxins, which leads to more damage.

One common symptom of liver damage is jaundice, a yellowish or greenish coloring of the skin. Other symptoms of liver damage tend to be vague and can include tenderness or swelling of the liver, nausea, and loss of appetite. One type of liver disease is

hepatitis or inflammation of the liver. Hepatitis is known as a viral disease, but it can also be caused by chemical substances. Hepatitis will usually heal without lasting damage except in severe cases. Then scarring of the liver (cirrhosis of the liver) can result. Some typical substances that can cause liver damage are metals like lead and arsenic, polychlorinated biphenyls (PCBs), and many solvents, including toluene, xylene, ethyl alcohol, and especially chlorinated solvents such as carbon tetrachloride and perchloroethylene.

KIDNEYS

Kidney damage can result from exposure to such substances as lead, arsenic, cadmium, mercury, selenium, uranium, chlorinated hydrocarbons, and turpentine. Bladder cancer may result from exposure to benzidine-derived direct dyes (used for dyeing cotton and silk). Silk-kimono painters in Japan, for example, who used these dyes have a high rate of bladder cancer. Most companies are replacing these dyes although they can still be found on the market.

NERVOUS SYSTEM

The nervous system is very susceptible to damage, and except for the peripheral nerves, damage is permanent. In particular, the brain can only survive for a few minutes without oxygen, and chemicals that interfere with the oxygen supply can cause brain damage. The brain can also be poisoned by chemical substances like carbon disulfide, hydrogen sulfide, and hydrogen cyanide. Heavy metals, like lead, mercury, and arsenic can cause nerve-function disorders and even death.

Many substances have a narcotic effect and cause depression of the central nervous system. Symptoms include intoxication, loss of coordination, dizziness, headaches, nausea and in severe exposures blackout and even death. I have seen several instances of artists being in car accidents or being arrested for drunken driving after working with organic solvents that are strong central-nervous-system depressants. Examples of these are alcohols, chlorinated hydrocarbons, toluene, xylene, and ketones.

Evidence has accumulated since the late 1970's that chronic exposure to high concentrations of many solvents can cause irreversible brain damage, called chronic toxic encephalopathy. Symptoms include memory loss, emotional swings, confusion, problems with

hand-eye coordination, lowered IQ, and other psychoneurological changes. Solvents that appear to be associated with this brain damage include the chlorinated hydrocarbons, mineral spirits, and aromatic hydrocarbons (see the solvents section in the next chapter).

Some chemicals can damage the peripheral nervous system (hands, arms, feet, and legs). Examples include lead, arsenic, mercury, methyl butyl ketone (found in some lacquer thinners) and n-hexane (found in low-boiling naphthas, some spray adhesives, and rubber cements and their thinners). In severe cases, there may also be permanent central-nervous-system damage.

THE REPRODUCTIVE SYSTEM

We can divide the effect of chemicals on the reproductive system into three basic categories: effects prior to pregnancy, effects during pregnancy, and effects on the newborn infant and child.

Prior to pregnancy, some chemicals (including those used in art) may affect both men and women. Reactions include interference with sexual function (e.g., loss of sex drive), lowered fertility, genetic damage, and difficulty in conceiving. Women can develop menstrual disorders, and men can develop problems with the testes and prostate.

Lead, for example, cause menstrual disorders in women, and loss of sex drive, atrophy of the testes and possible sperm alteration in men. It is also thought to cause decreased fertility and mutations. Glycol ethers may cause sterility in men and testicular atrophy. Carbon disulfide, a solvent, also severely affects the reproductive systems of both men and women. Cadmium and manganese may affect the male reproductive system. Toluene and xylene can cause menstrual problems.

Some epidemiological studies have shown that the wives of chemical workers have higher rates of miscarriages and stillbirths. Animal studies have similarly shown that the offspring of animals exposed to many chemicals have higher rates of miscarriages, stillbirths, birth defects, etc. Prior to pregnancy, exposures of the man are probably more important than exposures of the woman. The reason for this is that women have all their eggs from birth, and once a month an egg goes through a short developmental period, whereas men are constantly producing sperm. Since it takes about three months for sperm to fully mature, there is an extended period

for men prior to pregnancy when sperm can be damaged, possibly resulting in harm to the future fetus. Some chemicals, called mutagens, might cause mutations in the sperm that might cause birth defects that can be inherited and passed from generation to generation. Unfortunately, very few studies have been done in this area.

Chemicals causing damage during pregnancy can affect either the pregnant woman or the developing fetus. In the first case, the effect is due to the fact that during pregnancy a woman's metabolism is very different from normal. The amount of blood volume increases 30 to 40 percent without increasing the amount of iron. This can make a pregnant woman more susceptible to chemicals like lead and benzene, which can cause anemia. In addition, pregnant women are susceptible to respiratory problems and certain types of physical strain.

Many chemicals—called teratogens—can damage the growing fetus, even when present in very small amounts, and cause severe birth defects. Thalidomide is a classic example. Other chemicals are fetotoxic and may cause spontaneous abortions and miscarriages. Examples of chemicals that are teratogenic or fetotoxic include many metals (for example, lead and cadmium); many organic solvents (benzene, toluene, xylene, glycol ethers, chlorinated hydrocarbons, carbon disulfide); carbon monoxide (cigarette smoking causes underweight babies); anesthetic gases, aspirin, and many others. In addition, some chemicals may cause cancer in the children of women exposed to them during pregnancy. Examples are some pesticides and diethylstilbestrol (DES).

Finally, many chemicals can injure infants and children. One example is poisoning of an infant caused by breastfeeding when the mother has been exposed to toxic chemicals. (For example, methylene chloride has been shown to be present in the mother's milk up to seventeen hours after exposure). Other problems include exposure caused by children being present when toxic substances are being used, and the carrying home of toxic dusts on clothes and shoes. An eighteen-month-old girl got lead poisoning because she played in the area where her parents were doing stained glass.

One major problem is that most chemicals—including most art materials—have not been tested to see if they cause mutations or other types of damage to sperm or eggs before pregnancy, or if they damage the fetus during pregnancy. It is becoming evident that many chemicals might do so.

The best advise I can give prospective parents is similar to the advice doctors give pregnant women about medications: avoid medications if possible, not because we don't know if they are dangerous, but because we don't know if they are safe. Therefore, a prospective male parent should avoid exposure to toxic chemicals for the three months prior to an intended pregnancy, and a pregnant woman should avoid exposure during the entire pregnancy.

Note that I do not mean avoiding toxic chemicals. I mean don't use them if they will get into the body. If the only hazard is skin absorption or accidental ingestion—for example, painting with acrylics or watercolors—then careful work habits such as wearing gloves and not eating while you work can ensure that the chemicals do not get into the body. I recommend against oil painting with solvents at these times because it is too difficult to completely avoid inhalation of the solvent vapors. Of course, if you have adequate local exhaust ventilation for a process that eliminates inhalation problems, then solvents and other toxic airborne chemicals can also be used. For art students who cannot control what other students are using, special arrangements such as separate work areas or avoiding certain classes might by necessary.

Obviously, this approach doesn't work for unplanned pregnancies, both since the male parent doesn't know to take extra precautions beforehand, and the female parent usually doesn't know she is pregnant for at least several weeks, and the first twelve weeks of pregnancy are the most risky. This makes it crucial to minimize exposures to toxic chemicals at all times.

SOLVENTS AND AEROSOL

SPRAYS

olvents are one of the most underrated art hazards. They are used for a million purposes: to dissolve and mix with oils, resins, varnishes, and inks; to remove paint, varnish, and lacquers; to clean brushes, tools, silk screens, and even hands. As a result, artists are continually being exposed to solvents.

Almost all organic solvents are poisonous if swallowed or inhaled in sufficient quantity, and most cause dermatitis after sufficient skin contact. High concentrations of most solvents can cause narcosis (dizziness, nausea, fatigue, loss of coordination, coma and the like). This can increase the chances for mistakes and accidents. As mentioned earlier, long-term exposure to high concentrations of many solvents may cause brain damage. In particular, aromatic hydrocarbons, aliphatic hydrocarbons, and chlorinated hydrocarbons appear to be implicated. Some solvents—for example, benzene (benzol) and carbon tetrachloride—are so toxic that they shouldn't be used. Other solvents—for example, acetone and ethanol (ethyl or grain alcohol)—are reasonably safe.

Solvents fall into several classes with similar properties. If one member of a class of solvents is toxic, usually another safer member can be chosen.

Alcohols are generally anesthetics and irritants of the eyes and upper respiratory tract. In high concentrations, methanol (wood or methyl alcohol) can cause dizziness, intoxication, blurred vision, and possible liver and kidney damage. If swallowed, it can

cause blindness and even death. Ethanol, available as denatured alcohol containing some methanol, is a safer solvent. Amyl alcohol acts on the nervous system, causing dizziness, nausea, vomiting, and double vision.

Aromatic hydrocarbons are among the most dangerous solvents. They may be absorbed through the skin, although their major hazard is by inhalation. In general they are strong narcotics. The most dangerous is benzene (benzol), which causes chronic poisoning from the cumulative effect of exposure to small amounts. Its effects are destruction of bone marrow, leading to a loss of red and white blood cells, and sometimes leukemia. Toluene (toluol) doesn't have the long-term chronic effects of benzene on the bone marrow, but may cause liver and kidney damage. Its immediate effects can be more severe than those of benzene if a person is exposed to a high enough concentration. Toluene may also cause adverse reproductive effects. With proper ventilation, however, toluene is a suggested replacement for benzene. Xylene (xylol) is similar to toluene. Styrene is more toxic than toluene or xylene and may cause respiratory irritation, narcosis, and liver, kidney, and possibly nerve damage. Uses: resin solvent, paint and varnish remover, fluorescent dye solvent, common silk screen wash-up, lacquer thinners, aerosol spray cans, and others.

Chlorinated hydrocarbons, like aromatic hydrocarbons, are very hazardous. Some have been used as anesthetics in the past, but were found to be too toxic. All of them dissolve the fatty layer of the skin and can cause dermatitis. They also cause liver and kidney damage. Drinking alcohol after exposure to many chlorinated hydrocarbons can make people very sick. One of the most toxic chlorinated hydrocarbons is carbon tetrachloride and it shouldn't be used. It can be absorbed through the skin and exposure to small amounts can cause severe liver and kidney damage. Exposure to larger amounts can cause unconsciousness and death, especially if alcoholic beverages are ingested. Other toxic chlorinated hydrocarbons include tetrachloroethane (acetylene tetrachloride), chloroform, ethylene dichloride, perchloroethylene and trichloroethylene. The last four solvents have been shown to cause liver cancer in mice. Methyl chloroform (1,1,1-trichloroethane) appears to be less toxic than other chlorinated hydrocarbons at low concentrations, but has caused many fatalities when inhaled at high concentrations (for example, "glue sniffing" or working in enclosed

spaces). Methylene chloride (dichloromethane) is highly volatile and high concentrations may cause narcosis, lung irritation, pulmonary edema, and is a probable human carcinogen. Methylene chloride also decomposes in the body to form carbon monoxide and inhalation of large amounts has resulted in fatal heart attacks. People with heart problems and smokers are particularly at high risk. Although most of the chlorinated hydrocarbons are not flammable, they may decompose in the presence of ultraviolet light or excess heat (e.g., a lit cigarette) to form the poison gas phosgene. In general, try to replace chlorinated hydrocarbons with less toxic solvents. Uses: wax, oil, resin, grease and plastics solvent, paint strippers.

Aliphatic hydrocarbons, also called petroleum distillates, tend to be less toxic than most other solvents. They have a mild narcotic effect and, in large amounts, can cause lung irritation. If ingested, they may cause pulmonary edema (chemical pneumonia) and possible death due to aspiration into the lungs. Petroleum distillates are also skin irritants. *n*-Hexane, one of the most volatile petroleum distillates, may cause peripheral neuropathy—nerve damage and possible paralysis of arms and legs—from chronic inhalation of large amounts. These symptoms will disappear after a couple of years, but sometimes, with very high exposures, permanent damage to the central nervous system can result. Hexane is found in "extremely flammable" rubber cements and their thinners, in some aerosol spray adhesives and other aerosol spray products, and in low-boiling naphtha (petroleum ether). In recent years, hexane has been replaced by the less toxic heptane in many products. Other petroleum distillates, in increasing order of boiling point, are gasoline, benzine (VM&P Naphtha), mineral spirits (odorless paint thinner, turpentine substitutes, white spirits), and kerosene. Normal mineral spirits has about 15–20% aromatic hydrocarbons. Odorless mineral spirits and turpenoid have these more toxic aromatic hydrocarbons removed, and are recommended as substitutes for regular mineral spirits and turpentine. Uses: paint thinners, rubber-cement thinners, silk-screen poster inks, cleanup solvent, and similar products.

Esters are eye, nose and throat irritants and have anesthetic effects. Most common acetates are not skin irritants or sensitizers. Ethyl acetate is the least toxic, followed by methyl and amyl ace-

tates. They have good odor-warning properties. Uses: lacquer, resin, and plastics solvent.

Glycol ethers and their acetates recently have been found to be much more toxic than previously thought. Methyl cellosolve (ethylene glycol monomethyl ether) and butyl cellosolve (ethylene glycol monobutyl ether) were known to cause anemia and kidney damage. Cellosolve (ethylene glycol monoethyl ether) and its acetate were considered less toxic. Animal and human studies, however, show that cellosolve, methyl cellosolve and their acetates can cause birth defects, miscarriages, testicular atrophy, and sterility at low levels. All glycol ethers need study to determine if they also cause adverse reproductive effects. Uses: photoresists, color photography, lacquer thinners, paints, aerosol sprays.

Ketones cause narcosis and irritation to the eyes and upper respiratory tract in high concentrations. Their odor-warning properties are a good indication of the degree of exposure. They also cause defatting of the skin upon prolonged exposure, resulting in dry, scaly, cracked skin. Acetone is one of the safest solvents (except for its high flammability) and does not seem to have any lasting effects. Methyl ethyl ketone (MEK) is more toxic than acetone. Methyl butyl ketone may cause peripheral neuropathy similar to that caused by *n*-hexane. Methyl ethyl ketone acts synergistically with both *n*-hexane and methyl butyl ketone to cause neuropathy at levels that neither would by itself. Other highly toxic ketones include cyclohexanone and isophorone. Uses: solvents for lacquers, oils, waxes, plastics, vinyl silk screen inks, and so forth.

Another common solvent, *turpentine,* is a common oil paint and varnish thinner. Turpentines from many sources are skin irritants and sensitizers for many people, and can be absorbed through the skin. Their vapors are irritating to the eyes, nose, and throat upon prolonged exposure, and some turpentines may cause severe kidney damage. Resulting symptoms include headaches, gastritis, anxiety, and mental confusion. Turpentine is highly poisonous by ingestion; one tablespoon may be fatal to a child.

Citrus solvents (d-limonene) have been touted as non-toxic. They are definitely less hazardous by ingestion than most other solvents, although they often have a citrus-like odor that has caused children to drink them when they have been carelessly left around. They can still make a child sick, but are less likely to cause fatalities.

There have been some reports of skin, eye and respiratory irritation from their use.

AEROSOL SPRAYS

Artists are using a multitude of aerosol sprays today: fixatives, retouching sprays, paint sprays, varnishes, adhesive sprays, and the like. Aerosol sprays are very dangerous unless used so that neither the user nor someone nearby breathes the vapors. The fine mists containing possible toxic substances, such as paints, varnish, and adhesives, can remain in the air for hours before settling. Further, they penetrate deep into the lungs. Beside the dangers from the substances dissolved in the sprays, the solvents and propellants are often a hazard.

For example, many sprays contain toluol and chlorinated hydrocarbons. In spray form, these solvents may be more dangerous than in vapor form because the mists contain large quantities of solvents. Concern about propellants mounted when it was disclosed that in the early 1970's many spray products contain vinyl chloride, a chemical that has been shown to cause liver cancer. These products have been withdrawn from the market. Many propellants and solvents used in aerosol cans are also highly flammable.

Air brushes and spray guns are also highly hazardous since they also produce fine mists that can enter the lungs.

5

▲

ACIDS AND ALKALIS

Concentrated acids are very corrosive to the skin, eyes, respiratory system, and gastrointestinal system. Dilute acids can cause skin irritation on repeated or prolonged contact. If acid is spilled on your skin, wash with lots of water. In case of eye contact, rinse your eyes with water for at least fifteen minutes and contact a physician. An important safety rule when mixing acids is to add the acid to the water, not the other way around. Strong acids include glacial acetic, carbolic (phenol), chromic, hydrochloric, nitric, sulfuric, hydrofluoric, and perchloric acids. Chromic acid is also a skin sensitizer. The gases produced from etching metals with nitric acid are very dangerous since they burn the lungs and may result in pulmonary edema (fluid in the lungs). Uses: cleaning metals, etching metals, dyeing assistants, photochemicals, glass etching, and the like.

Concentrated alkalis can cause severe burning of the skin and eyes, respiratory and gastrointestinal systems from a single exposure while dilute alkalis can cause skin irritation from repeated or prolonged exposure. Eyes are particularly susceptible. Potassium hydroxide (caustic potash) and sodium hydroxide (caustic soda) are the most dangerous; other alkalis that cause burns are sodium carbonate, potassium carbonate, calcium oxide (quicklime or unslaked lime), sodium metasilicate, sodium silicate, and ammonia. Ammonia vapors and quicklime dust can also damage the lungs. Uses: dyeing assistants, ceramics, photo chemicals, paint removers, and similar materials.

part

T W O

▲

HAZARDS
OF
VARIOUS
MEDIA

6

▲

PAINTING AND DRAWING

ainters use many different media: traditional ones like oil, tempera, encaustic, water color, gouache, and fresco; and modern ones, mostly acrylic, but including media like alkyd, ethyl silicate, vinyl acetate, and other synthetics. In these media, the artist uses many different pigments, vehicles, solvents (thinners, paint and varnish removers, and the like), varnishes, and other materials.

Common drawing materials include pen and ink, pencil, charcoal, graphite, pastels, oil pastels, and felt-tip markers. Spray fixatives are commonly used to protect drawings.

PIGMENTS

Most artists are aware of the dangers of lead pigments and don't handle them in powder form because of the danger of inhaling the dust. Even ready-to-use lead paints are very dangerous to handle, and such precautions as carefully washing hands and fingernails after using them are crucial, to avoid accidentally carrying the lead paint to the mouth and subsequently ingesting it.

Many artists, however, are not aware that many other inorganic pigments in common use can be hazardous due to the presence of other toxic compounds. (See Table 1.) Inhalation of the powdered pigments or of spray mist from air brushing the paints, or accidental ingestion of the pigments from pointing the brush with your mouth, or eating, drinking, or smoking while working, can result in chronic poisoning. In particular, the chromate pigments and cadmium pigments are known or suspected to

T A B L E 1 HAZARDOUS INORGANIC PIGMENTS	
ARSENIC:	emerald green (no longer used)
	cobalt violet (cobalt arsenate type)
ANTIMONY:	true Naples yellow (lead antimoniate)
CADMIUM:	all cadmium pigments
CHROMIUM:	zinc yellow (zinc chromate)
	strontium yellow (strontium chromate)
	chrome yellow (lead chromate)
COBALT:	cobalt violet (cobalt phosphate or arsenate)
	cobalt green (cobalt and zinc oxides)
	cobalt yellow (potassium cobaltinitrite)
	cerulean blue (cobalt and tin oxides)
LEAD:	flake white (basic lead carbonate)
	lead white (basic lead carbonate)
	cremnitz white (basic lead carbonate)
	mixed white (basic lead carbonate and zinc oxide)
	true Naples yellow (lead antimoniate)
	chrome yellow (lead chromate)
MANGANESE:	manganese blue (barium manganate and barium sulfate)
	manganese violet (manganese ammonium phosphate)
	burnt umber (manganese dioxide)
	raw umber (includes manganese silicates)
	Mars brown (manganese dioxide)
MERCURY:	vermilion (mercuric sulfide)
	cadmium vermilion red (cadmium mercuric sulfide)

cause cancer. The cobalt arsenate form of cobalt violet should never be used because of its extreme acute toxicity.

Other pigments besides those containing heavy metals can be hazardous. Lampblack, for example, can cause skin cancer. In addition, the toxicity of many of the modern synthetic organic pigments is unknown. Some of the metallic driers used with pigments are also toxic because they contain lead or manganese, although they are only present in small amounts. Cobalt linoleate is the least toxic drier.

VEHICLES

The vehicles and binders used in the traditional media (such as drying oils, egg yolk, gums, casein) are essentially nontoxic. One exception is quicklime, which is both a skin and lung irritant, with inhalation of the dust possibly leading to chemical pneumonia. Wax in encaustic can decompose to produce strong lung irritants if overheated, and the wax vapors are flammable.

Mineral spirits and turpentine are commonly used as thinners and in some oil painting mediums. These solvents are also present in the modern alkyd and solvent-based acrylic paints. As discussed earlier, these solvents are hazardous by skin contact, inhalation, and ingestion and require good ventilation.

The commonest modern vehicle is water-based acrylic emulsion. Many acrylic emulsions contain a small amount of ammonia and formaldehyde. This causes the odor of some acrylic emulsions and may cause irritation of the eyes, nose, and throat if used without ventilation. The formaldehyde may cause allergic reactions in people who are already sensitized to formaldehyde. Formaldehyde may also be present as a preservative in some other water-based media.

Other types of paints sometimes used by artists—including house paints, automotive paints, and epoxy paints—can contain a wide variety of toxic solvents, preservatives (including mercury compounds), and other chemicals, and should be investigated before being used.

VARNISHES

Here the solvents are the major hazard. The various solvents used include methyl alcohol and ethanol (shellac varnish), turpentine (damar, mastic, and cooked oil-resin varnishes), and the lacquer solvents used with pyroxylin and other synthetic resins. The major hazard in lacquer thinners is due to the presence of toluene and possibly glycol ethers.

DRAWING MATERIALS

Most common dry drawing materials (pencil, chalk, charcoal, graphite, oil pastels) are not considered hazardous, although you do not want to inhale large amounts of any dust. In particular, the

habit of blowing excess dust off the drawing can result in inhalation of large amounts of dust. Pastels can be more hazardous since many pastels contain toxic pigments, just like paints. In recent years, several major pastel manufacturers have been removing the toxic metal pigments from their pastels. However, no pastel dusts should be inhaled.

The use of spray fixatives (or hair spray used by some people) to protect drawings is an inhalation hazard, especially because of the presence of toxic solvents. They should be used outdoors or in a spray booth.

Permanent felt-tip markers contain solvents, usually xylene or alcohols. There have been instances of liver damage from the long-term use of lots of xylene-based markers without proper ventilation. The alcohol-based markers are less toxic, and water-based markers even safer. Solvent-based drawing inks often contain aromatic hydrocarbons and are highly toxic. They need good ventilation.

7

▲

PRINTMAKING

Printmaking methods use a variety of solvents and solvent mixtures. Again, aromatic hydrocarbons (xylene and toluene) and lacquer thinners are hazardous and should be used with adequate ventilation. Benzene should be avoided. Cleaning should be done with the least toxic solvent possible.

Inks used in black-and-white printing usually contain carbon black. Some carbon blacks can be contaminated with polycyclic aromatic hydrocarbons, a known cause of cancer. Avoidance of skin contact and careful washing after exposure is helpful. Common toxic pigments used in printmaking include most of the pigments found in painting. (See Table 1.) In addition, lead pigments are much more common in printmaking and include chrome yellow (lead chromate), chrome green or Milori green (lead chromate and potassium ferrocyanide), and molybdate orange (lead chromate, lead molybdate, and lead sulfate). As mentioned previously, the hazards of the synthetic organic pigments have not been well studied, and there is growing concern about their toxicity. Except for the solvent-based silk screen inks, most printmaking inks contain water or linseed oil as the vehicle.

SILK SCREEN PRINTING

In silk screen printing with solvent-based inks, the solvents are the biggest health hazards, with exposure coming during screen preparation, printing, drying of the prints, and washup. Very careful local exhaust ventilation of work areas is needed to prevent a dangerous buildup of vapors in the air. Drying of the prints should be done in a drying rack equipped with local exhaust ventilation or in front of an

explosion-proof window exhaust fan. Since most of the solvents are skin irritants, skin contact with them should be avoided as much as possible through use of gloves, especially during washup.

The solvents used depend on the type of ink and the stencil media used. For example, most poster, enamel and fluorescent inks can be washed up with mineral spirits or mineral spirits with about 15 percent added toluene or xylene for the difficult parts. Many companies sell proprietary washups consisting of pure aromatic solvents, like xylene or the more toxic trimethylbenzenes. Lacquer inks and vinyl inks usually require more toxic solvents.

Switching to the use of water-based silk screen inks is the best solution to the many hazards of using solvent-based inks. In recent years the quality of water-based inks have improved remarkably. As a result, many schools and colleges are now using the water-based inks.

The use of lacquer stencils with water-based inks is hazardous unless proper ventilation is present. There are many ways to avoid lacquer stencils, including diazo photoemulsions (not the more hazardous dichromate types, which can cause skin ulcers, allergic reactions, and possible cancer), cut paper stencils, adhesive-based contact paper, etc.

RELIEF PRINTING

Traditional wood-cutting and engraving techniques can cause the potentially crippling carpel tunnel syndrome, which involves pressure on the median nerve running through the wrist due to abnormal bending of the wrist. Symptoms include pain, numbness, and/or pins and needles in the thumb and first three fingers.

Oil-based inks require the use of solvents for cleanup, whereas water-based inks don't. Other relief methods, for example, collage, can also be hazardous if they use toxic solvents and glues. Linoleum etching with caustic soda (sodium hydroxide) can cause severe skin burns.

INTAGLIO

Etching grounds basically consist of asphaltum (pitch in oil or turpentine base), beeswax, and rosin; liquid grounds also contain solvents like benzine, or in the case of some commercial ones, ether or methyl chloroform. The asphalt or pitch is a skin irritant and may

cause skin cancer. Rosin dust is a sensitizer, and inhalation can cause hay-fever-type symptoms and possibly asthma. This is particularly a problem in aquatinting. Rosin dust and asphaltum dusts are explosive, and there have been explosions involving rosin dust boxes resulting from sparks from the use of non-explosion-proof parts.

One of the greatest hazards in intaglio is the acid etches. Acids, especially when concentrated, cause severe skin burns. Eye damage from splashes can also be very dangerous. Remember always to add acid to water, never the reverse. Nitric acid etching of zinc produces highly toxic nitrogen dioxide gas that can dissolve in the lungs to cause chemical pneumonia from large exposure, or emphysema and chronic bronchitis from repeated exposures to smaller amounts. Hydrochloric acid (used in Dutch mordant) can cause similar lung problems. Potassium chlorate, also used in Dutch mordant, is a skin irritant and, when mixed with organic materials, is explosive. Mixing of the hydrochloric acid and potassium chlorate to produce Dutch mordant releases poisonous chlorine gas. A safer alternative is iron perchloride (ferric chloride).

Engraving, drypoint and mezzotint involve the repetitive use of tools which can cause carpel tunnel syndrome similar to that caused by wood-cutting. Although intaglio inks are based on linseed oil, solvents are used for cleanup.

LITHOGRAPHY

Lithographic drawing materials like lithographic crayons and tusches may contain carbon black, and sometimes solvents are used for thinning. Lithographic etches consist of the relatively safe gum arabic and dilute acid. Prepared etches are safer than handling concentrated acids to make your own. In particular, the extremely toxic hydrofluoric acid should not be used. Rosin dust may cause asthma in some people, and only asbestos-free talcs (e.g., baby powder) should be used. Washout of the image is done with solvents, and needs ventilation. Counteretches or fountain solutions containing dichromates should not be used. Dilute acetic acid can be used as a counteretch, and water with a bit of gum arabic used for a fountain solution. As with intaglio, lithographic inks are based on processed linseed oil, but solvents are used for cleanup.

Metal plate processing often uses acid counteretches and vinyl lacquers containing highly toxic solvents to fortify the image

for long runs. These vinyl lacquers should not be used unless adequate local exhaust ventilation is present.

PHOTO TECHNIQUES

Photolithography, photoetching, and photo silk screen techniques are common today. One of the greatest hazards in these techniques lies in the widespread use of unvented carbon arcs for exposure. Carbon arc electrodes consist of carbon, tar, pitch, and rare earth fillers with a copper coating. When lit, the carbon arc produces toxic carbon monoxide, nitrogen oxides, ozone, and toxic metal fumes. The gases and fumes, especially ozone and nitrogen oxides can cause severe chronic lung problems, including emphysema after repeated exposure. One problem is that dangerous amounts of fumes can be inhaled without noticeable discomfort. Carbon arcs must be directly vented to the outside by an overhead or canopy hood. In addition, carbon arcs produce large amounts of ultraviolet light that can cause severe eye damage if UV-absorbing goggles or hand shields are not used. Walls should be painted with UV-absorbing zinc oxide to reduce reflection of ultraviolet light. Using light sources other than carbon arcs is highly recommended.

Photoetching used several highly toxic solvents. KPR Photo-Resist, for example, contains ethylene glycol mono-methylether acetate (methyl cellosolve acetate, a glycol ether), which affects the blood, liver, and nervous system through both inhalation and skin absorption. It is also known to cause adverse reproductive effects in both male and female animals, and humans. The KPR developer and dye both contain toluene. Gloves should be worn when handling these chemicals and these solutions should only be used with excellent local exhaust ventilation.

Photoetching should be done with less-hazardous materials to replace the highly toxic solvents used with the KPR process. One recently developed technique involves the silk screening of Borden's condensed milk onto the copper or zinc plate, using a diazo photoemulsion on the screen.

Photolithography can involve the use of toxic solvents. In addition, the classic gum-bichromate method involves the use of highly toxic dichromate solutions, which can cause skin ulcers, allergies, and possibly cancer.

Photo silk screen can use direct emulsions or indirect emul-

sions. Direct emulsions involve either ammonium dichromate or the much less toxic diazo types, or adhering presensitized films to the screen. The screens are then exposed and then developed. Indirect emulsions involve adhering sensitized transfer screens after exposure. Chlorine bleaches, which are skin, eye, and respiratory irritants, are often used to remove the photoemulsions.

8

▲

CERAMICS

Hazards in ceramics fall into three basic categories: the hazards of clays, the hazards of glazes and colorants, and the hazards during the firing process.

CLAYS

Clays contain silicates and varying amounts of crystalline-free silica (SiO_2). Inhalation of silica dust from handling the clay in dry form can lead to silicosis or "potter's rot." Symptoms may take years to develop and include shortness of breath, decreased chest expansion, and increased susceptibility to infections. Eventually, severe scarring of the lungs can result. Inhaling large quantities of kaolin dust can also cause lung scarring.

Many low-fire clays and slip-casting clays contain talc, which can be contaminated with asbestos. This is especially true of New York talcs. Inhalation of asbestos over years of exposure can cause lung cancer, mesothelioma (cancer of the lining of the chest or abdominal cavity) and asbestosis, a form of lung scarring. Some companies are starting to introduce talc-free clays and asbestos-free talcs.

The most hazardous operations are the mixing of clay dust, and the breaking up of dry grog. Installation of local exhaust ventilation, using wet clay, or wearing toxic dust respirators are recommended precautions. The contamination of the studio with dry clay dust is also a major hazard, requiring careful cleanup by wet mopping or vacuuming with a vacuum cleaner with high efficiency HEPA filters.

GLAZES AND COLORANTS

Glazes also contain free silica, often in the form of flint, silica, feldspar and talc, which contribute to the risk of developing silicosis.

In addition, glazes also contain toxic metals such as lead, barium, and lithium. Among glaze materials, those containing lead are the most toxic. The use of lead frits decreases but does not eliminate the hazard since many lead frits are fairly soluble in stomach acid. I have seen cases of lead poisoning from both raw lead glazes and lead frits. I recommend not using lead. Food and drink containers made with lead may leach into the food or drink. Other toxic glaze materials include asbestos and alkali oxides.

Many of the colorants contain toxic metals like antimony, chromium, manganese, uranium, cadmium, and vanadium. Nickel compounds are skin sensitizers and known cancer-causing agents. Cadmium, chromates (lead chromate, zinc chromate, and iron chromate), and uranium oxide may cause lung cancer.

The mixing of glazes from the powders and spraying of glazes are the most hazardous steps. Toxic dust respirators should be worn when mixing glazes. Spraying should only be done in a spray booth exhausted to the outside. Special precautions are needed with solvent-containing glazes.

FIRING

During the firing process, toxic fumes and gases are produced. During the bisque firings, toxic carbon monoxide, sulfur dioxide and formaldehyde can be released from the clays. Fluorine, chlorine, and sulfur dioxide can be released from the breakdown of the raw glazes to the oxides, and some metals such as lead, cadmium, and others can vaporize during the firing process. Gas-fired kilns can produce large amounts of carbon monoxide gas, especially during the reduction stages.

All kilns—both electric and gas-fired—must be ventilated. A window exhaust fan might suffice for small electric kilns but overhead canopy hoods are preferred. Direct vent systems developed by the Orton Ceramic Foundation also provide good ventilation. Gas kilns should also have canopy hoods with powered exhaust.

Potters have developed cataracts from looking in the kiln peephole over a period of years. This is due to the infrared radiation produced when objects are heated to high temperatures. Infrared goggles or a hand-held infrared shield should be used (shade number 2 or 3).

9

▲

STONE, PLASTER, CLAY, AND WAX SCULPTURE

STONE

Sculptors use a variety of techniques to work stone, including chipping, grinding, and carving. Some hazards are obvious—for example, the danger of eye injury from flying chips. This is why sculptors should always wear protective goggles when chipping or grinding.

But there is also a long-term danger from working with certain stones—that of silicosis. Known to many workers as "grinder's consumption" or "stone-mason's disease," silicosis results from the repeated inhalation of dust containing free silica. As previously noted, silicosis affects breathing capacity and resistance to respiratory disease, and results in scar tissue in the lungs.

Stones containing large amounts of free silica include quartz (100 percent silica), granite, sandstone, brownstone, slate, jasper, opal, amethyst, onyx, and often soapstone. Other stones that may contain some free silica include diabase and serpentine.

Soapstone, serpentine, and greenstone often contain asbestos as a contaminant. Inhalation of asbestos can cause lung cancer, mesothelioma (cancer of the lining of the chest and abdominal cavity), and asbestosis.

If you work with pneumatic tools, other dangers are present. The vibration can cause "white fingers" or "dead fingers," a circulatory system disease also known as Raynaud's phenomenon.

41

This particularly happens when the hands are chilled; permanent disability can result after repeated exposures. Frequent work breaks, comfortable hand grips on the pneumatic tools, and keeping your hands warm are some ways to combat "white fingers." In addition, the noise from the pneumatic equipment, unless muffled properly, can cause hearing loss.

PLASTER

Plaster of paris (calcium sulfate) is irritating to the eyes and slightly irritating to the respiratory system. When working with large amounts of plaster of paris dust, a NIOSH-approved dust respirator should be worn. Some additives, such as lime, can be much more hazardous.

One serious problem that has occurred with plaster casting is severe burns from the casting of body parts. In several instances children and adults making plaster casts of hands or arms have been severely burned due to excess buildup of heat during the setting process. This process should never be done with children.

CLAY

There are two basic types of modeling clay: water-based and oil-based. The hazards of regular wet clay and its dust are discussed in the previous chapter. Oil-based modeling clay is less hazardous than wet clay, although some people might be allergic to some of the components in the oil-based clay.

WAX

Natural waxes such as beeswax and petroleum waxes such as microcrystalline wax and paraffin wax are by themselves not hazardous. However, when they are heated, both fire and decomposition problems can occur. Wax should never be heated with an open flame or on a hot plate with an exposed element. Overheating can cause the wax to decompose into strong lung irritants such as acrolein and formaldehyde. You should always use a heat source with fine temperature control and heat the wax to the lowest workable temperature to minimize vaporization and decomposition of the wax.

Chlorinated waxes, especially polychlorinated terphenyls, have sometimes been used as foundry casting waxes. These waxes

are extremely dangerous and may cause a severe skin disease called chloracne, liver damage, and possible reproductive damage and cancer. They are chemically related to polychlorinated biphenyls (PCBs) and should *never* be used.

Solvents are often used to remove wax. Some books recommend such extremely dangerous solvents as carbon tetrachloride and benzene. A less toxic solvent is benzine (VM&P Naphtha) or odorless mineral spirits. A kneader eraser can also be used.

10

▲

WOODWORKING

Woodworkers are subject to a large number of occupational health problems resulting from exposure to the woods, especially tropical woods, solvents, adhesives, noise, and vibration.

Many woods can cause skin irritation and allergies; such woods include South American boxwood, cocobolo, ebony, American and African mahogany, mansonia, rosewood, walnut, East Indian and other satinwoods, and Western Red Cedar.

Chronic inhalation of sawdust can cause chronic respiratory diseases. In particular, cocobolo, ebony, African mahogany, mansonia, rosewood, and stainwood can cause respiratory irritation and allergies. Beech, iroko, Western Red Cedar, and teak can cause severe asthma. South American boxwood, cork oak, and redwood can cause an acute illness resembling pneumonia; it appears a few hours after exposure with symptoms of shortness of breath, dry coughing, chills, sweating, fever, and weight loss. A person with this usually recovers from a first attack without any ill effects but repeated exposures can cause lung scarring and decreased lung capacity.

Workers in hardwoods are also at higher risk than the rest of the population for developing nasal and nasal sinus cancer, especially adenocarcinoma. This disease develops in 7 in 10,000 woodworkers annually, usually occurring forty years after first exposure. It is not known whether this is also true for workers in softwoods.

Paint strippers and finishes contain many different toxic solvents, including toluene, methyl alcohol, methylene chloride and—up to 1978—benzene (benzol), which can cause leukemia. Other hazards faced by woodworkers include toxic preservatives (such as pentachlorophenol, arsenic compounds, and creosote—all

44

of which may cause cancer and reproductive problems), adhesives (e.g. epoxy resins, solvent-based contact adhesives), vibration from pneumatic tools, and noise from woodworking machines and pneumatic tools.

Proper precautions include dust collectors for woodworking machines, ventilation for solvents, good housekeeping, and proper personal protective equipment.

11

▲

PLASTICS SCULPTURE

Plastics are used in every part of our lives without any harmful effects that we know of. But the processes used to make and fabricate plastics can be very dangerous. Many occupational diseases are found among plastic workers. And sculptors using these processes are subject to the same diseases.

The degree of hazard depends on whether you are making the plastic or are working with the finished plastic (e.g., sanding, cutting, carving, vacuum-forming, and similar activities).

Plastics consists of large numbers of long chain-like molecules made from smaller molecules (called monomers) linked together. These long chainlike molecules are called polymers, and the process of linking the monomers together is called polymerization. In thermoplastics, the polymers lie side by side and can move when heated to fill different shapes. In thermosetting plastics, on the other hand, the long polymeric molecules are joined together or "cross-linked" by smaller molecules or by heat. The process of turning thermoplastics into thermosetting ones by cross-linking is called curing. Heating thermosetting plastics does not change their shape.

The greatest hazards arise when you are working with the monomers, solvent, fillers, catalysts, and hardeners used in making plastics. Many of the monomers in particular are toxic. This is what you are doing when you are working with casting, laminating, and foam processes.

The hazards involved in working with finished plastics come mostly from the methods used to work the plastic. Overheating or burning of plastic can result in the release of toxic gases from the decomposition of the plastic. This can occur during sawing or

machining. Heating of plastics can sometimes result in the release of unreacted monomer, plasticizers, or other chemicals that are trapped in the plastic. Plastic dusts created in the sawing, sanding, and polishing of plastics can sometimes create lung problems. And the glues and cements used to bond plastics often contain toxic solvents and plastic monomers.

With these factors in mind, let's look at the hazards involved in working with particular plastics.

ACRYLICS

Methyl methacrylate (MMA) monomer or combinations of MMA with acrylic polymers can be used for casting and laminating. When combined with a catalyst (e.g., benzoyl peroxide) and heated, the mixture cures to a clear solid.

Methyl methacrylate is a skin sensitizer and irritant, and its vapors cause nausea, loss of appetite, headaches, and lowering of blood pressure. Benzoyl peroxide, like most peroxides, is flammable, explosive, a skin irritant, and a skin sensitizer. Peroxides are also very damaging to the eyes, so care should be taken to avoid contact with the eyes.

The main hazards in working with the finished acrylic sheets and blocks (plexiglass and lucite) are in inhalation of the dusts or heat decomposition products (MMA monomer and, at higher temperatures, carbon monoxide), and in the use of acrylic glues and cements. Cements consist of pure solvents (methylene dichloride, ethylene dichloride, trichloroethane), of acrylic chips dissolved in these solvents, or of acrylic monomers, and have the same hazards as are involved in polymerizing these monomers, as discussed above. All of the above types of cements require good ventilation.

POLYESTER RESINS

Polyester resins used for casting and laminating are very hazardous and require excellent ventilation or respirators. These are also called fiberglass resins because fiberglass is used for reinforcement. The normal resin consists of a nontoxic polyester dissolved in styrene monomer that acts as a cross-linker. To cure the resin, a catalyst (methyl ethyl ketone peroxide or benzoyl peroxide) is added. Some polyester resins also contain MMA monomer to give a clear casting resin.

Styrene monomer is an aromatic hydrocarbon similar to toluene or xylene, and, like these solvents, is highly toxic. Styrene is a strong irritant to the skin, eyes, and respiratory system and a powerful narcotic, and may cause liver and nerve damage from repeated exposure.

Methyl ethyl ketone peroxide (MEKP) is flammable and explosive in pure form, but is diluted with dimethyl phthalate for normal use. It should not be allowed to dry out and should not be heated. Methyl ethyl ketone peroxide can also cause blindness if splashed in the eyes; goggles should always be worn when using it.

The dangers of working with polyester resins were described by sculptor Robert Mallary in an article called "The Air of Art is Poisoned" (*Art News,* October 1963).

EPOXY RESINS

Epoxy resins are used in laminating, casting, glues, and lacquer coatings. They consist of two components: an uncured epoxy resin and a hardener. The uncured epoxy resin is a skin irritant, sensitizer, and suspected cancer-causing agent.

The hardeners, especially amines, are strong sensitizers and irritants in minute quantities, and have been a major source of adverse reactions among users. During the curing process, large amounts of heat are produced that can cause dangerous fuming of the hardener. Overheating of the cured resin during sawing, sanding, and such activities can produce irritating decomposition products. Handling of epoxies requires careful precautions to avoid skin contact and inhalation.

POLYURETHANES

Polyurethanes are used in several forms. Urethane rubber is used as a flexible mold; urethane foam can be used for sculptures or cast. They consist of two components: an isocyanate one, and a polyol component that also contains catalysts and other additives.

The diisocyanates (TDI, MDI) used to make polyurethanes are very toxic. Inhalation of isocyanates can cause severe lung problems, with symptoms of breathlessness, chest discomfort, and reduced lung function. Exposure to high concentrations has caused, within minutes, severe lung irritation and coughing spasms.

Massive exposure may also lead to bronchitis, bronchial spasms, and/or pulmonary edema (chemical pneumonia). Small amounts can cause severe acute and chronic asthma. Isocyanates can also cause skin and eye problems.

The catalysts used are irritating to the eyes, lungs, and upper respiratory tract, and may cause liver and kidney damage, skin sensitization, and irritation. Fluorocarbon blowing agents used with foams may cause loss of feeling, unconsciousness, and heart arrhythmias at high concentrations.

Obviously, making polyurethanes is very hazardous. In casting polyurethanes, have local exhaust ventilation (e.g., spray booth) or wear an approved respirator. Do not spray polyurethane resins unless you are wearing a self-contained breathing apparatus.

VINYL POLYMERS

These include polyvinyl chloride (PVC), polyvinyl acetate (PVA), PVC/PVA copolymers, and polyvinyl alcohol. They are thermoplastics and can be heat-molded, vacuum-formed, and so forth. In heat welding of PVC at high temperatures, care must be taken to avoid breathing toxic hydrogen chloride fumes released from the decomposition of PVC. In the past, contamination of polyvinyl chloride by vinyl chloride monomer was a serious hazard since vinyl chloride monomer causes liver cancer in humans.

POLYSTYRENES

Polystyrene is available as sheets that can be cut and shaped, as molding pellets that can be fused, as foam sheets (Styrofoam) that can be cut with hot wire cutters, and as expandable polystyrene beads for foam molding. Cutting or sawing of factory-fresh or very large slabs of Styrofoam releases the colorless, odorless gas methyl chloride, and can release any trapped styrene monomer. In small amounts, methyl chloride can cause symptoms of drunkenness; in large amounts, dizziness, staggering, and even death. It is also a suspected carcinogen and teratogen.

Open flames should be avoided when using expandable polystyrene beads since they contain flammable pentane gas. Some styrene cements used to cement Styrofoam contain styrene monomer.

OTHER PLASTICS

Room-temperature-vulcanizing (RTV) silicone rubber is a common mold-making material. It is available as both a two-component system and a one-component system. The two-component system uses peroxides as a curing agent. These are irritants and sensitizers, and they are flammable. The one-component system cures by interacting with atmospheric moisture and usually gives off acetic acid vapors during curing. These can cause respiratory irritation.

Rubber cement, used in paste-up, contains natural rubber dissolved in low-boiling petroleum distillates, usually hexane until recently. The rubber-cement thinner is also usually hexane. *n*-Hexane can cause nerve damage as discussed in Chapter 4. Good ventilation is needed. Rubber cements containing heptane are safer, but still require ventilation.

Fluorocarbons (e.g., Teflon, TPFE) are safe unless heated to decomposition. The decomposition products can cause polymer fume fever, with symptoms that are very similar to a severe case of the flu. Moderate heat, for example lit cigarettes, can create this problem.

ADDITIVES

There are many different types of additives used in plastics resins, including fillers, plasticizers, and pigments. I shall only comment on a few of the more hazardous.

Fiberglass is commonly used in laminating. It is very irritating to the skin and causes many fine cuts that make it easier for other chemicals to cause irritation. Dust respirators should be worn when sanding plastics containing fiberglass, since the glass dust is irritating to the lungs. Some modern specialized fiberglass materials are similar in size to asbestos fibers and have caused cancer in animals. This fiberglass, however, is not readily available.

Many fillers contain free silica, and inhalation of the dust should be avoided. Probably the most hazardous substance to use is asbestos. Inhalation of even small amounts of asbestos dust can cause cancer. In general, many additives are hazardous, so skin contact and inhalation of vapors or dusts should be avoided.

12

▲

METALWORKING

METAL CASTING

Most sculptors send out large pieces to a commercial foundry to be cast into metal. A few do their own metal casting; this is particularly popular at art schools. The lost-wax process of metal casting is often used for casting small pieces. The commonest metals and alloys used are bronze, aluminum, brass, pewter, iron, and stainless steel. Gold, silver, and sometimes platinum are used for casting small jewelry pieces.

Mold-making techniques for metal casting use sand and, with some modern techniques, phenol-formaldehyde or urea-formaldehyde resins as binders. The formaldehyde is a strong lung irritant, may cause asthma, and causes nasal cancer in animals. In addition, the resin can decompose from the heat of the casting process to produce toxic formaldehyde, phenolic, and/or ammonia vapors. The hexamethylenetetramine used as a catalyst for the resin is a strong skin, ear, eye, nose, and throat irritant and a skin sensitizer. Good ventilation is needed with these resin sands. Protection is also needed against the silica content of the sand.

In the lost-wax process, the wax pattern is covered with a casting investment containing plaster and cristobalite, a highly toxic form of silica that has caused silicosis in jewelers. The cristobalite can be replaced with 30-mesh sand, which is much safer. Then the wax is burnt out in a burnout kiln, which requires ventilation due to the highly irritating wax decomposition products. A variation of the lost-wax process uses polyurethane foam or styrofoam to make the positive mold. Decomposition of the foam

during the casting process can release toxic gases, including hydrogen cyanide.

In the casting process, the metal is melted and then poured into the mold. The fumes of many of these metals and alloys are toxic. The metal fumes may cause an acute disease called metal fume fever. This is especially true of zinc oxide fumes, but oxides of copper, iron, magnesium, and nickel can also cause metal fume fever. Symptoms are very similar to those of the flu—chills, fever, nausea, weakness, and aches—and appear a few hours after exposure. Metal fume fever lasts about a day and a half, but recovery is complete.

Other health problems can also result from exposure to metal fumes. Inhalation of the lead fumes from bronze (or from lead casting) can cause lead poisoning. Other toxic metals include nickel, which can cause allergic reactions and possible lung or nasal cancer; manganese, which can cause chemical pneumonia or manganism—which is very similar to Parkinson's Disease; and chromium, which can cause lung cancer. In particular, the common practice of using junk metals for casting can be very dangerous since these may be coated with lead pigments, mercury-containing paints, cadmium, and the like.

Another problem is the carbon monoxide produced from incomplete combustion of fuels used for melting the metal, and from the burning of sea coal and other organic materials found in the molding sand. This is a problem during the pouring.

The melting furnace requires a canopy hood exhausted to the outside and there should be good ventilation for the pouring operation.

Another hazard in casting is the large amount of heat released. Unless workers are shielded from the heat, they may develop heat-stress diseases. In addition, the infrared (IR) radiation produced can cause burns unless the skin is covered. Unless proper goggles are worn, repeated exposure of the eyes to IR radiation may cause infrared cataracts. Removing the mold after the casting is complete can also involve the risk of inhalation of silica dust.

FORGING

Cold forging uses a wide variety of hammers, mallets, anvils, and similar tools to change the shape of metal. Hot forging involves the heating of the metal to make it easier to shape. Both types of

forging create huge amounts of noise, which can damage people's hearing. Some precautions to diminish the noise hazard include having good tools, isolating the forging areas from other people, and wearing proper hearing protectors.

Hot forging involves the burning of gas, coke, or other fuels. The forge needs to be ventilated with a canopy hood to exhaust the carbon monoxide produced. This hood will also reduce heat buildup. Infrared goggles should be worn for protection against infrared radiation.

SURFACE TREATMENT

Surface treatment of metals can involve mechanical treatment (chasing, repousse) with hammers, engraving with sharp tools, etching with acids, photoetching, electroplating and electroforming, and metal coloring. Many of these have been discussed in other chapters.

Electroplating and electroforming with gold and silver often use cyanide salts, which can be fatal even from ingestion of small amounts. In addition, accidental mixture of acids and cyanide solution will produce deadly hydrogen cyanide gas. This is hazardous through both skin absorption and inhalation; death can occur within minutes. I recommend against electroplating with cyanide solutions. Instead, send it to a commercial shop.

A variety of chemicals is used to color metals. Some are applied cold, others hot. Many of these are toxic by themselves—for example, lead and arsenic compounds—while others can give off extremely toxic gases when heated. For example, potassium ferricyanide solutions will give off hydrogen cyanide gas when heated, arsenic/acid solutions give off arsine gas, and sulfide solutions give off hydrogen sulfide gas. Very good ventilation is needed for metal coloring and I would recommend against using arsenic compounds or heating potassium ferrocyanide solutions.

FINISHING PROCESSES

Cleaning, grinding, filing, sandblasting, and polishing are some final treatments for metal. Cleaning involves the use of acids (pickling). This involves the hazards of handling acids and of the gases produced during the pickling process (such as nitrogen dioxide from nitric acid). Grinding can result in the production of fine

metal dusts, which can be inhaled, and heavy flying particles, which are eye hazards.

Sandblasting—more correctly called abrasive blasting—is very hazardous, especially if sand is used. Inhalation of fine silica from abrasive blasting with sand can cause a rapidly developing silicosis in a couple of years. Sand should be replaced with glass beads, aluminum oxide, or silicon carbide. Foundry slags should only be used if chemical analysis shows no silica or dangerous metals such as arsenic or nickel. Good ventilation or respiratory protection is needed for abrasive blasting.

Polishing with abrasives such as rouge (iron oxide) or tripoli can be hazardous since rouge can be contaminated with large amounts of free silica and tripoli contains silica. Good ventilation of the polishing wheel is needed.

13

▲

WELDING

Physical hazards in welding include the danger of fire, electric shock from arc-welding equipment, burns caused by molten metal sparks, and burns caused by excessive exposure to infrared, visible, and ultraviolet radiation. For example, sparks from arc welding can travel up to 40 feet.

Infrared radiation generates large amounts of heat, which can cause burns, headaches, fatigue, and eye damage. Ultraviolet radiation can cause sunburn; repeated exposure may lead to skin cancer. Electric arc welders in particular are subject to pink eye (conjunctivitis), and some have cornea damage from exposure to the UV radiation. These hazards point out the need for careful skin and eye protection when welding.

Chemical hazards depend on the type of welding technique and on the metals being welded. Oxyacetylene torches produce carbon monoxide, which ties up the blood's hemoglobin, and also unburned acetylene, which is a mild intoxicant. In addition, commercial acetylene contains small amounts of other toxic gases and impurities.

Metal welding, particularly arc welding, produces enough energy to convert the air's nitrogen and oxygen to nitrogen oxides and ozone. Nitrogen dioxide is highly irritating to the eyes, nose, and respiratory tract. Exposure to large amounts can cause chemical pneumonia, emphysema, and even death. Ozone is an eye, nose, and throat irritant and it is a severe lung irritant, causing chemical pneumonia, hemorrhage, shortness of breath, headache, and drowsiness. Chronic exposure can cause chronic bronchitis and premature aging of lung tissue.

If welding is carried on within 200 feet of degreasing solvents (chlorinated hydrocarbons), phosgene gas can be produced by the action of ultraviolet radiation on the chlorinated hydrocarbons. Even minute amounts of phosgene gas, a poison gas used in World War I, can be deadly, and its effects often don't appear for hours after exposure.

Metal fumes are generated by the vaporization of metals, metal alloys, and the electrodes used in arc welding. The hazards of metal fumes have been discussed in the previous chapter on metal casting, and can include metal fume fever, lead poisoning, and other ailments. In addition, fluoride fluxes produce fluoride fumes. These fumes dissolve in the lungs to produce hydrofluoric acid, which is highly corrosive and can cause severe burning of the lungs besides affecting teeth, bones, skin, and other parts of the body.

Many metal dusts and fumes can cause skin irritation and sensitization. These include brass dust (copper, zinc, lead, and tin), cadmium, nickel, titanium, and chromium. In addition, there are problems with welding materials that may be coated with various substances. For example, many metals are coated with lead paint, mercury-containing anti-fouling paint, and the like.

14

▲

JEWELRY AND ENAMELING

JEWELRY

Many jewelry techniques are identical to those of metal sculpture, but on a smaller scale. These include the lost-wax method of casting gold, silver, and platinum, and fabrication and finishing processes.

Because of the lower melting points of gold and silver, these metals are not welded but are brazed at a lower temperature. Silver soldering in particular can be hazardous. The lowest-melting silver solders can contain up to about 30 percent cadmium. Cadmium fumes can cause chemical pneumonia from a single overexposure. In one example, a person died in 1967 from inhaling cadmium fumes when brazing with a silver solder containing cadmium. Chronic exposure can cause kidney damage, chronic lung damage, lung cancer, and possibly prostate cancer. Cadmium-containing silver solders should be replaced with cadmium-free solders.

Fluoride fluxes are commonly used with silver solders. Fluoride fumes can cause respiratory irritation, including nosebleeds and ulceration. Borax fluxes are safer.

Sulfuric acid solutions or Sparex solutions (sodium hydrogen sulfate) are used to clean metal. Concentrated sulfuric acid is corrosive to skin, eyes, and respiratory system. Preferably, use the less toxic Sparex—though Sparex solutions are also acidic and can cause dermatitis. In addition, heating the acid solutions releases sulfur dioxide gas, a lung irritant. Many asthmatics in particular are sensitive to sulfur dioxide.

Because of the high cost of gold and silver, electroplating is becoming more popular. This can be extremely hazardous due to

the presence of cyanide salts in gold and some other electroplating solutions. As discussed under metalworking, I strongly recommend against electroplating with cyanide solutions.

ENAMELING

Most copper enamels available in the past were lead-based, although lead-free enamels are now commonly being sold by major manufacturers. Lead poisoning can occur from inhalation or ingestion of the lead enamel powders, from spraying, and possibly from firing of the enamels.

Enamels can contain other toxic metals besides lead, including nickel, manganese, chromium, and cobalt. Uranium oxide, which is radioactive, was banned as an enamel colorant in 1984 by the Nuclear Regulatory Commission.

Precautions include using lead-free enamels, wearing a toxic dust mask when mixing or applying enamel powders, spraying enamels in a spray booth, providing enameling kilns with exhaust ventilation, and good housekeeping.

Heated enamels give off infrared (IR) radiation, and exposure over a period of years has caused infrared cataracts in enamelists. Wear infrared goggles when using enameling kilns.

15

▲

STAINED GLASS AND GLASSBLOWING

STAINED GLASS

One of the main hazards in stained glasswork is lead poisoning. I know of several diagnosed cases among stained glass workers—both among those using lead came and those using the copper-foil technique. Both techniques involve soldering with lead/tin solders, and there is the danger of inhaling the lead solder fumes, especially if the solder (and lead came) are overheated, as can happen with torches or overly powered electric soldering irons. In addition, the settled lead fumes can coat surfaces and be transferred to hands and to the mouth. Since the copper-foil technique uses large amounts of solder, this technique can involve an even greater risk. With lead came, there is the additional risk of inhalation or accidental ingestion of lead dust from cutting or sanding the lead came. This can be particularly a hazard if you eat, drink, or smoke while you're working, or don't wash up carefully after work. Remember that other family members can also be at risk if you work at home. A few years ago, an eighteen-month-old child developed lead poisoning as a result of being present when her parents were doing their stained glass work in the kitchen.

High-lead solders should be replaced with lead-free and, preferably, antimony-free solders that have been developed in recent years.

59

Acid fluxes (zinc chloride, muriatic acid) can cause skin burns, and the fumes are strong respiratory irritants, and can cause bronchitis from high exposures. More likely is the development of chronic bronchitis from repeated inhalation of small amounts of the acid fumes. The fumes from other fluxes are also irritating to the lungs, but to a lesser extent. Inhalation of rosin core fluxes may cause asthma. Ventilation is needed for both the soldering and flux fumes (e.g., working at a bench in front of a window with a window exhaust fan at work level).

Hydrofluoric acid used for glass etching is highly poisonous. It can cause severe and painful burns, especially under the fingernails. One problem is that there is no burning sensation until several hours after exposure. Inhalation causes severe respiratory irritation and possible pulmonary edema. It can also affect the bones and teeth. Fluoride pastes are safer to work with, although they produce hydrofluoric acid in solution. Gloves should always be worn and proper ventilation provided. Zephiran chloride solution or calcium gluconate gel should be available as an antidote.

Stained glass can involve many other techniques to color and decorate the glass. Many different patinas are used on the lead came. Copper sulfate is highly toxic by ingestion; skin contact may cause dermatitis, and inhalation may cause congestion and perforation of the nasal septum. Antimony poisoning often resembles arsenic poisoning. Silver nitrate is moderately corrosive to the skin and respiratory system, and highly corrosive to the eyes, and can cause blindness. Selenium dioxide, sometimes used as a patina, is a skin irritant. In combination with strong acid it can produce the highly poisonous gas hydrogen selenide.

GLASSBLOWING

Making your own glass from the raw materials is very dangerous because of the hazards of the raw materials: lead compounds, silica, colorants, and so forth. These hazards are similar to those of ceramics when people mix their own glazes (see Chapter 8.) The recent development of pre-mixed, pelletized batches makes this process less hazardous. A safer procedure used by many glass artists is to buy scrap glass (cullet) and melt it in the furnace.

Gas-fired furnaces require canopy hoods to exhaust carbon monoxide and any gases emitted from the glass raw materials.

Infrared goggles are needed to protect eyes against the large amounts of infrared radiation produced, which can cause "glass-blower's cataracts." Heat is a major hazard in glassblowing and glass artists should take precautions against heat stroke and other heat-induced illnesses.

A variety of chemicals is used for coloring and decorating glass. Many are applied to the hot glass and can be vaporized to produce toxic fumes. For example, zinc fuming can cause metal fume fever. Other metals can produce more serious poisoning. Etching glass with hydrofluoric acid and abrasive blasting have been discussed earlier.

16

▲

TEXTILE ARTS

The textile arts include a variety of processes, including spinning, weaving, crocheting, knitting, dyeing, photoprinting. I will discuss only some of the main hazards here.

FIBER ARTS

Most of the hazards in the fiber arts come from dust problems. This is particularly a hazard in early stages of processing like spinning, where fiber dust is present. Most fiber dusts can cause respiratory irritation and sometimes allergies when regularly inhaled. Cotton, flax, and hemp dusts can cause brown lung or byssinosis after years of exposure. In its early stages, symptoms of shortness of breath, chest tightness, and increased sputum flow appear only when a person returns to work after a few days' absence. This stage is reversible. In more advanced stages, symptoms are very serious and are present all the time. At this stage the disease is not reversible and resembles chronic bronchitis and emphysema.

Imported animal fibers, especially goat hair from the Mid-East and Central Asia carry the risk of anthrax, a serious bacterial disease due to the presence of anthrax spores. This has two forms: a skin form and an inhalation form ("wool-sorter's disease"). The inhalation form is usually fatal; in 1976 a California weaver died of respiratory anthrax. All imported wool or yarn from countries when anthrax is common should be decontaminated, preferably before being sold.

Other hazards with fibers or fabric include respiratory allergies or irritation from synthetic materials due to the possible presence of formaldehyde resins, physical strain from constant un-

comfortable positions in weaving, and the use of toxic chemicals (e.g., fire retardants).

DYEING

Hazards in dyeing come from the dyes, mordants, and other dyeing assistants. Direct dyes used for cotton, linen, and rayon in the past were made from benzidine or benzidine derivatives, all known carcinogens. Studies have also shown that the dyes made from these chemicals can cause bladder cancer. Silk kimono painters in Japan who use these dyes, for example, have a high rate of bladder cancer. This may in part be due to their habit of pointing their brushes with their lips. All-purpose household dyes contain a mixture of direct, acid, and basic dyes and, up until a few years ago, also contained benzidine-type dyes. The hazards of the dyes they are using now have not been well studied.

Fiber-reactive dyes, including cold-water dyes, can cause severe respiratory allergies, usually after several years of exposure. This can include asthma, "hay fever," swelling of the eyes and face, and similar ailments. People who have developed an allergy to these dyes usually cannot work with them any more.

Pre-reduced or pre-solubilized vat dyes are caustic to the skin and respiratory system. Lye (sodium hydroxide), caustic soda, and sodium hydrosulfite used as dyeing assistants with vat dyes are corrosive to the skin, eyes, and respiratory system.

Azoic or naphthol dyes come in two parts, a "fast salt" and a "fast base." They may cause dermatitis and hyperpigmentation. Their long-term effects have not been adequately studied.

The long-term effects of many acid dyes, used for silk and wool, have also not been adequately studied. Many food dyes, which are usually acid dyes, have been banned because studies showed they caused cancer in animals. Acetic acid, formic acid, and sulfuric acid, sometimes used as dyeing assistants with acid dyes, can cause eye and respiratory irritation and skin burns. Glauber's salt (sodium sulfate), used with acid dyes, is not very toxic.

Basic dyes, used for wool, silk, and some synthetics, may cause allergic responses in some people.

The long-term hazards of natural and synthetic mordant dyes have not been adequately studied. However, many of the mordants used with these dyes can be hazardous. In particular,

sodium or ammonium dichromate can cause allergies, burns, and skin ulcers, and are probable human carcinogens. Inhalation of the powder may also cause perforation of the nasal septum. Other mordants are also toxic, especially copper sulfate, ammonia, and oxalic acid.

BATIK

Wax vapors are flammable and wax should never be heated with an open flame or hot plate with an exposed element. When over-heated, the wax decomposes to release highly irritating formalde-hyde and acrolein fumes. Heat wax to the lowest temperature that is effective. Use a hot plate or electric frying pan with fine tempera-ture control. Wax decomposition is also a problem when ironing out the wax. This process should be well ventilated. If you use solvents to remove the wax, do not use the extremely toxic carbon tetrachloride. Instead, use odorless mineral spirits with good ven-tilation, or send your piece to the cleaners.

PHOTOPRINTING

The ferric ammonium citrate and potassium ferricyanide used in blueprinting (cyanotype) are only slightly toxic. The silver nitrate used in brownprinting (Van Dyke process) is moderately corrosive by skin contact and inhalation, and is highly corrosive to the eyes and may cause blindness. Silver nitrate should only be sprayed in a spray booth or while wearing a full-face respirator with a dusts and mists filter.

Carbon arcs, often used as a source of ultraviolet light, produce highly toxic ozone, nitrogen oxides, and carbon monox-ide, as well as UV light. In addition, the potassium ferricyanide used in blueprinting will react with the ultraviolet radiation from the carbon arc to produce poisonous hydrogen cyanide gas. Carbon arcs should not be used as a light source.

17

▲

PHOTOGRAPHY

Many of the chemicals used in photographic processing can cause severe skin problems, and, in some cases, lung problems through inhalation of dusts and vapor. The greatest hazard occurs during the preparation and handling of concentrated stock solutions of the various chemicals. During these steps in particular, it is essential to wear protective gloves and goggles (to protect against splashes). Special care should be taken to avoid skin contact with powders and to avoid stirring up dusts that can be inhaled. Use a glove box (see page 93) or toxic dust respirator when mixing powders. Good ventilation is important to get rid of vapors and gases, especially from the fixer.

Simple black-and-white processing includes developing, stop bath, fixing, and rinsing steps. The developer often contains hydroquinone and Metol (monomethyl *p*-aminophenol sulfate), both of which can cause skin irritation and allergic reactions. Many other developers are even more toxic. Developers are also toxic by inhalation of the powders and ingestion, causing methemoglobinemia and cyanosis (blue lips and fingernails due to oxygen deficiency). These are dissolved in an alkaline solution containing sodium hydroxide, which can cause skin irritation and even burns. Tongs should be used so that hands are never put into the developer. If skin contact does occur, the skin should be washed copiously with water and then with an acid-type skin cleanser.

The stop-bath consists of a weak solution of acetic acid. The concentrated glacial acetic acid can cause burns; inhalation of the stop-bath vapors can irritate the breathing passages and throat. Potassium chrome alum, sometimes used as a stop hardener, con-

tains chromium and can cause ulcerations, especially in cuts and nasal membranes, and allergies.

The fixer usually contains sodium sulfite, acetic acid, sodium thiosulfate (hypo), boric acid, and potassium alum. Hypo and the mixture of sodium sulfite and acids produce sulfur dioxide, which is highly irritating to the lungs. Asthmatics are often very sensitive to sulfur dioxide. Potassium alum, a hardener, is a weak sensitizer and may cause some skin dermatitis.

Many intensifiers (bleaches) can be dangerous. The common two-component chrome intensifiers contain potassium dichromate and hydrochloric acid. The separate components can cause burns, and the mixture produces chromic acid. Its vapors are very corrosive and may cause lung cancer. One common bleach, potassium chlorochromate, also produces chlorine gas if heated or treated with acid. Handling of the powder of another intensifier, mercuric chloride, is very hazardous because of possible mercury poisoning. Mercuric chloride is also a skin irritant and can be absorbed through the skin. It should not be used.

The commonest reducer contains potassium ferricyanide. If it comes into contact with heat, concentrated acids, or ultraviolet radiation, the extremely poisonous hydrogen cyanide gas can be released. Otherwise, it is only slightly toxic.

Many toners contain highly toxic chemicals. These include selenium, uranium, sulfide or liver of sulfur (corrosive to skin and breathing passages), gold and platinum (allergies), and oxalic acid (corrosive). Sulfide toners also produce highly toxic hydrogen sulfide gas, and selenium toners produce large amounts of sulfur dioxide.

Hardeners and stabilizers often contain formaldehyde, which is poisonous, very irritating to the eyes, throat, and breathing passages, and can cause dermatitis. It also causes nasal cancer in animals. Some of the solutions used to clean negatives contain harmful chlorinated hydrocarbons.

Color processing involves many of the same chemicals that are used in black-and-white processing. Developers also contain dye couplers, which can cause severe skin problems, and some solutions contain toxic organic solvents. Formaldehyde is a common ingredient of some color-processing systems.

Kodak recommends at least 170 cubic feet/minute of dilution ventilation for standard photoprocessing. The exhaust opening

should be located just above and behind the fixer and stop-bath trays. For darkrooms with several work stations, multiply 170 times the number of fixer trays to get the total amount of ventilation recommended. Toning and color tray processing should have local exhaust ventilation.

18

▲

COMMERCIAL ART

Commercial art includes such techniques as drawing, painting, retouching, and paste-up of mechanicals. A wide variety of materials is used—including paints, dyes, inks, bleaches, spray fixatives and adhesives, rubber cement, and solvents—which can be applied by pen, brush, swab, felt marker, aerosol spray can, or air brush.

In the past, rubber cement and rubber cement thinner used for paste-up usually contained large amounts of extremely flammable and highly toxic hexane. n-Hexane can cause dermatitis, narcosis from inhalation of large amounts at any one time, and peripheral neuropathy (inflammation and possible paralysis of arms and legs) from chronic inhalation of large amounts. Recently, many companies have replaced hexane with the less toxic (but still flammable) heptane. Good ventilation is needed for rubber cement and thinners.

Paints can be either water-based (water color, acrylic, gouache), solvent-based (alkyd, lacquer), or oil-based. With water-based paints the only concern is with the pigments, as discussed in Chapter 6. When painting with a brush, one is concerned about ingestion or getting the paints in cuts. With air brushing, pigments can be inhaled, which is much more hazardous, especially with highly toxic pigments like chrome yellow, zinc yellow, cadmium, and manganese colors. For paints that use solvents, the hazards of solvent inhalation are found with both brush painting and air brush, although air brushing is more hazardous because you are inhaling large amounts of solvents.

Preferably, air brushing should be done in a spray booth. Otherwise, respiratory protection is needed. For water-based

paints, you need a respirator with a paint spray or dusts and mists filter. For solvent-containing paints, you need a respirator with an organic vapor cartridge and spray prefilter. The use of solvents for cleaning also requires ventilation.

Dyes are used in felt markers, colored inks, spray markers, and liquid water colors. The hazards of most of these dyes are unknown since few long-term toxicity studies have been carried out. They can be water-based (liquid water colors, water-soluble felt markers) or solvent-based (permanent markers, spray markers, many colored inks). A wide variety of solvents is used, but the highly toxic aromatic hydrocarbons such as toluene and xylene are among the most common. These require very good ventilation. Alcohol-based markers are safer. If the dyes are sprayed, then a spray booth or respirator with a spray prefilter and an organic vapor cartridge (for solvent types) is essential. The use of bleaches to remove the dyes from the skin is not recommended since the bleach can cause dermatitis. It is better to avoid skin contact in the first place—for example, through the use of barrier creams or gloves.

Spray fixatives and spray adhesives are commonly used in commercial art. They are very toxic by inhalation due to the presence of solvents. Toluene, chlorinated hydrocarbons, and petroleum distillates are common as solvents. Petroleum distillates are not usually considered highly toxic unless they contain hexane, but in spray-mist form they may cause chemical pneumonia if substantial quantities enter the lungs. The long-term hazards of the adhesives are not known. However, hairdressers who use aerosol sprays regularly have been found to have a higher rate of chronic lung problems than the rest of the population.

Aerosol spray cans are also explosive and usually flammable. The replacement of freons by extremely flammable gases like propane has caused a great increase in the number of fires in the last several years. Whenever possible, aerosol sprays should be replaced by non-aerosol products. Mouth atomizers for spraying are not recommended because of the risk of liquid backing up into the mouth. Large amounts of spraying should be done in a spray booth.

Retouching of drawings, packages, photographs, and the like is another common commercial art technique. It uses all of the materials described above, as well as other materials specifically for photographic retouching. Freon and methyl chloroform (1,1,1-

trichloroethane) are commonly used for film cleaning. Freon is only slightly toxic, although in large quantities it may cause irregularities in heart rhythms. Methyl chloroform is one of the least toxic chlorinated hydrocarbons, although it can cause narcosis and also has been implicated in heart problems.

Iodine and potassium iodide in water are commonly used as a black-and-white bleach. Iodine is a strong skin irritant and is poisonous if ingested. Ethyl alcohol, which is only slightly toxic, is used as a stopping agent, and thiourea as a clearing agent. Thiourea is suspect as a cancer agent in humans since it causes cancer in animals.

A variety of chemicals is used for color bleaching. One of the commonest is potassium permanganate in diluted nitric or sulfuric acids. Sodium bisulfate is the clearing agent. Potassium permanganate is highly corrosive as the powder or concentrated solutions, and mildly irritating in dilute solution. When diluting the acids, always add the acid to the water, never the reverse. Wear rubber gloves and goggles. Sodium bisulfate decomposes in acid solutions to produce sulfur dioxide, which is highly irritating to the eyes and respiratory system.

In transparency retouching, potassium permanganate, sulfuric acid, and sodium chloride, or Chloramine-T and acetic acid are used to bleach yellow dyes. Do not add more potassium permanganate solution than specified in the directions because of the danger of producing highly toxic chlorine gas. Similarly, Chloramine-T releases chlorine gas in acid solutions. The Chloramine-T powder is also irritating to the skin, eyes, nose, and respiratory system, and causes allergic reactions. Use of all of the above bleaches requires local exhaust ventilation.

Stannous chloride and disodium EDTA are used as a magenta dye bleach. Stannous chloride solutions are skin irritants and the dust is a respiratory irritant. Disodium EDTA is highly toxic by ingestion, causing kidney damage and tetany (irregular muscular spasms of the extremities) due to calcium depletion. Sodium hydrosulfite (sodium dithionite) used in a cyan bleach is flammable and can decompose to produce sulfur dioxide. Sodium cyanide is occasionally used as a bleach. Sodium cyanide causes skin rashes and is extremely poisonous by ingestion and possibly by inhalation. Sodium cyanide reacts with acids to produce the poison gas hydrogen cyanide, which can be fatal by inhalation in minutes. I recommend

against using cyanide bleaches. (If you must, do so only in an efficient laboratory hood, have a cyanide antidote kit available at all times, and be close to the hospital.)

Gum arabic solution is often sprayed onto photographs as a fixative. Inhalation of gum arabic can cause "printers' asthma," so-called because about 50 percent of the printers who used to spray it became sensitized to gum arabic.

19

▲

CHILDREN AND ART

MATERIALS

Despite concern over lead poisoning in children and attempts to eliminate children's exposure to such lead-containing materials as wall paints and pencils, many children are still being exposed to lead in art classes in schools, community centers, and even the home. I have found lead-based pottery glazes and enamels in most elementary schools I have visited. Many people mistakenly assume that lead frits are "safe," whereas in actuality many commercial lead frits can dissolve in stomach acids. Other sources of lead in art materials sometimes used with children include silk-screen and other printmaking inks, lead solders, and stained glass.

Examples of lead poisoning in children include a child swallowing stencil paint that contained at least 30 percent lead, and an eighteen-month-old girl developing lead poisoning after being present in the kitchen where her parents were involved in stained-glass work. One of the problems is that these materials usually do not state that they contain lead nor do they carry warning labels.

Lead, however, isn't the only hazardous art material being used by children. The ingestion of one tablespoon of turpentine can be fatal to a child, and ingestion of two tablespoons of methyl alcohol (found in many shellacs) could have serious toxic effects, possibly including blindness. Other art materials that are toxic by single or repeated ingestion of small amounts include many solvents (paint thinner, kerosene, lacquer thinners, and the like), acids, alkalis, photographic chemicals, dyes, and many pottery glaze ingredients.

Ingestion, however, is not the only way in which art materials can injure children. Skin contact with many art materials can cause burns, irritation, ulcers, and allergies. Examples include solvents, which defat the skin; acids and alkalis, which can cause severe burns; formaldehyde and turpentine, which can cause skin allergies; and potassium dichromate (a natural dye mordant), which can cause skin and nose ulcers. If the skin has cuts or sores, then many toxic materials can enter the body through these breaks in the skin's defenses. In addition, many solvents can be absorbed through the skin into the body.

Finally, inhalation of solvent vapors, dusts, aerosol spray mists, and metal fumes can either injure the lungs or be absorbed through the lungs into the bloodstream. Common art materials containing hazardous solvents include turpentine, paint thinner, paint and varnish removers, rubber cement, silk-screen inks and solvents, lacquers and their thinners, shellac, permanent markers, cleaning solvents, aerosol spray cans, and solvent-based glues and adhesives. Hazardous dusts include asbestos, dry clay, glaze ingredients, dye powders, plaster dust, and sawdust. Other toxic art materials children may be exposed to include etching gases, kiln gases, soldering fumes, and gases from photographic developing.

WHAT IS THE RISK?

I believe that children under the age of about twelve should not be exposed to most hazardous materials. This conclusion is based on both physiological and psychological reasons.

First, children are at much higher risk physiologically from exposure to toxic materials than adults. There are several reasons for this. Children and teenagers are still growing and have a more rapid metabolism than adults. As a result, they are more likely to absorb toxic materials into their bodies. With young children this can especially affect the brain and nervous system. Young children also have smaller lungs and are therefore particularly more susceptible to inhalation hazards. Finally, children are at higher risk because of their smaller body weight. A certain amount of toxic material is more concentrated in a child's body than it is in a larger adult body. Therefore, the smaller the child, the greater the risk.

Second, children under the age of twelve cannot be depended upon either to understand the need to carry out precau-

tions or to carry them out effectively on a consistent basis. Pre-school children are likely to put things in their mouths deliberately and then swallow them, thus creating an even greater hazard. Even though older children might not deliberately swallow art materials, there have been several fatalities due to accidentally swallowing turpentine or paint thinner that had been carelessly stored in soda bottles, orange-juice containers, or similar containers. In addition, accidental ingestion can occur by placing contaminated hands in the mouth.

For these reasons, I recommend that children under the age of twelve not be allowed to use art materials that are hazardous by ingestion, skin contact, or inhalation. Junior and senior high school students, although they are still at higher risk than adults, are at an age when they might normally be expected to understand the need for precautions and to carry out precautions consistently. Of course this generalization has exceptions, particularly with mentally re-tarded or emotionally disturbed children. I would recommend, however, that even junior and senior high school students not use highly toxic materials like asbestos, lead, mercury, and cadmium, since even small exposures to these materials can have severe effects.

WHAT ART MATERIALS SHOULD CHILDREN USE?

Many art materials recommended in children's art books are highly toxic and should not be used by children.

This brings up the question: How can you tell which are materials are safe or whether children can work with them safely? Many children's art materials have a label stating that they are "non-toxic." Unfortunately, this label can be misleading since many children's art materials have not been tested for long-term toxicity, including possible cancer. Further, most art-material man-ufacturers do not have toxicologists or other personnel competent to evaluate the hazards of the art materials they are using.

The only program I know of that has attempted to ensure the safety of children's art materials is that of the Arts and Crafts Materials Institute (formerly Crayon, Watercolor and Craft In-stitute). Art materials carrying their Certified Product (CP) or Approved Product (AP) seal of approval have been "certified by an authority of toxicology, associated with a leading university, to

contain no materials in sufficient quantities to be toxic or injurious to the body, even if ingested." There are undoubtedly other safe children's art materials but I do not have verification of this.

The Labeling of Hazardous Art Materials Act of 1988 requires labeling of all chronically hazardous art materials. If there are hazards, the label must state that the product is not suitable for use by children. Properly labeled art materials carry the statement "Conforms to ASTM D-4236" or the equivalent. The law also gives the Consumer Product Safety Commission the power to obtain a court injunction against any school that purchases toxic art supplies for use in elementary school.

The following are some recommendations for the safe use of art materials with children:

▲ Do not allow children to use adult art materials. Use children's art materials with the AP or CP seal of the Arts and Crafts Materials Institute, or use art materials that carry the statement "Conforms to ASTM D-4236" and do not have any warning labels.

▲ Do not allow children to use solvents (e.g., turpentine, shellac, toluene, rubber cement thinner) or solvent-containing materials (solvent-based inks, alkyd paints, rubber cement, permanent felt tip markers, solvent-based glues, aerosol sprays). Instead, use water-based inks, paints, glues, etc.

▲ Do not allow children to use art materials containing toxic metals such as arsenic, cadmium, chromates, mercury, lead, manganese, or other toxic metals that may occur in pigments, metal filings, metal enamels, ceramic glazes, metal casting, stained glass, etc.

▲ Do not allow children to use or create powders. Some powders—such as powdered clay, synthetic dyes, pastels, pigments, glazes, etc.—contain toxic chemicals. But children may experience respiratory irritation from even relatively non-toxic powders such as children's temperas, plaster dust, etc. Either purchase the material in liquid or wet form (e.g., wet clay, liquid paints), or an adult can mix up the powders away from children. For dyeing, use vegetable and plant dyes (e.g., onionskins, spinach, tea, flowers) or food dyes.

▲ Do not allow children to use corrosive chemicals such as acids, alkalis, photochemicals, etc. Instead of photo-processing, do sungrams using blueprint paper and sunlight, or use Polaroid cameras.

▲ Do not allow children to do plaster casting of body parts. Serious burns have resulted from this process.

▲ Do not allow children to use scented felt tip markers. These teach children bad habits about eating and sniffing art materials.

▲ Clean the art area carefully so that toxic dusts such as clay and plaster do not accumulate where they can be inhaled by children (or teacher).

▲ Do not allow food or drink in the art area because of the risk of contamination—and make sure children wash their hands carefully after class. Make sure children do not have exposed cuts or sores on their hands.

▲ Ventilate all kilns, including electric kilns. Place the kilns in a room separate from the children.

part

THREE

▲

SAFETY IN THE STUDIO

20
▲

KNOW YOUR MATERIALS

In order to know how to work safely with art materials, you must first know what chemicals they contain and the properties of these chemicals. Several sources of information are useful for this purpose, including product labels, Material Safety Data Sheets, and reference sources.

PRODUCT LABELS

Warnings on the label of an art material should be your first alert as to whether the material is hazardous or not. At least this is true if the art materials is properly labeled, as required under the *Labeling of Hazardous Art Materials Act* of 1988. The campaign to obtain better labeling of art materials was discussed in Chapter 1.

The Labeling of Hazardous Art Materials Act of 1988 requires art and craft manufacturers to determine whether their products have the potential to cause chronic illness, and to place labels on those products that do. However, rather than leaving the criteria for chronic hazards up to individual manufacturers, the law requires that the Consumer Product Safety Commission (CPSC) develop guidelines for chronic hazards.

Many artists use products that were originally developed for industry. Examples include screen-printing inks and other screen printing products, plastics resins, ceramics materials, etc. Sometimes these are labeled "For Industrial Use Only." If an industrial product is sold in art supply stores or other locations where consumers can walk in and purchase it, if the manufacturer advertises it as suitable for making art, or sells it to schools, then it does have to

be labeled in accordance with the *Labeling of Hazardous Art Materials Act.*

If it does not meet these requirements, then the product does not have to be labeled as an art material. As discussed below in the section on Material Safety Data Sheets, if the product is hazardous, it would still have to be labeled with its identity and hazard information under the Hazard Communication Standard of the Occupational Safety and Health Administration (OSHA).

A proper warning label should have the following components:

A Signal Word: The signal word tells you the extent of the hazard. **DANGER** is the most serious, followed by **WARNING** and **CAUTION,** respectively. **DANGER** is used for products that are highly toxic, corrosive or extremely flammable. **WARNING** or **CAUTION** are used for substances that are less hazardous. **WARNING** is also used for products that only have chronic hazards.

A List of Potential Hazards: This section lists the known significant acute and chronic hazards under reasonably foreseeable use of the product. The hazards should be listed in order of descending severity and should specify the type of hazard. A rubber cement containing hexane, for example, should state "May damage central and peripheral nervous system by inhalation or skin contact." There must also be a warning that the product is "Extremely Flammable."

Name of Hazardous Component(s): This contains a list of the common or usual names of hazardous ingredients and known hazardous decomposition products, with acutely hazardous ingredients listed first. If there is no common name, then chemical names should be used. This should include known sensitizers present in sufficient amounts to cause allergic reactions in sensitized individuals. In the above example, the rubber cement should state "Contains *n*-Hexane."

Safe Handling Instructions: This section should include appropriate precautionary statements concerning fire safety, work practices, ventilation, and personal protection. For the rubber cement, this would include such statements as "Avoid inhaling vapors or skin contact. Use only with exhaust fans. When using, do not smoke, drink, or eat." There would also be fire precautions.

First Aid: This section includes recommendations for emergency first aid. For the rubber cement, this would include: "If swallowed, do not induce vomiting. Call Physician Immediately."

Sources of Further Information: This can include referrals to a local poison center, 24-hour emergency number, availability of MSDSs, and other information.

Other Statements: The label must carry the statement "Conforms to ASTM D-4236" or a similar statement. If there are warnings, then the label must also state that the product is not suitable for children.

MATERIAL SAFETY DATA SHEETS

Under the Hazard Communication Standard of the Occupational Safety and Health Administration (OSHA), manufacturers and importers are required to prepare Material Safety Data Sheets (MSDSs) on hazardous products to provide more detailed information on the hazards and precautions. A major problem is the MSDSs were originally intended for use by health and safety professionals and tend to be very technical. In addition, the quality of most MSDSs left much to be desired, especially in the area of chronic hazards.

One problem is that artists are not entitled to obtain MSDSs unless they are an employee since OSHA just applies to employers and employees. In addition, OSHA does not apply to public employees in states that do not have OSHA-approved state plans. However, most reputable manufacturers will send MSDSs even to self-employed individuals.

Figure 20–1 is the typical format of a MSDS. Manufacturers are not required to use this format as long as all the information specified is present. The MSDS must be in English. Blank spaces are not allowed on an MSDS. If a particular section is not applicable or no information is available, then the section must specify that.

The following are the requirements for a Material Safety Data Sheet:

Identity: The identity of the product should be the same name as found on the product label.

Section I: The MSDS must have the date of preparation, and the name, address, and telephone number of the chemical manufacturer, importer, employer or other party responsible for preparing the MSDS.

Section II - Hazardous Ingredients/Identity Information: This section must include the chemical and common names of hazardous ingredients. For mixtures that have been tested as a whole, only the ingredients found to be hazardous must be listed. If the mixture has not been tested, all toxic ingredients at a concentration greater than 1 percent must be listed, and all carcinogenic ingredients at concentrations over 0.1 percent. Materials are considered hazardous if they are listed in OSHA's Z list (29 CFR 1910, Subpart Z, Toxic and Hazardous Substances), if the American Conference of Governmental Industrial Hygienists has assigned a Threshold Limit Value (TLV) to the material, or if it has been found to be toxic, carcinogenic, irritating, sensitizing or damaging to certain body organs. Unfortunately, the MSDS does not have to list the percentage concentration of each ingredient.

This section must also have the OSHA Permissible Exposure Limit (PEL), the ACGIH Threshold Limit Value (TLV) or any other exposure limit used by the manufacturer.

The one exception to listing the chemical names or common names of hazardous ingredients, according to OSHA, is if the manufacturer claims and is able to document that it is a trade secret. In this case, the manufacturer must state on the MSDS that the identity of the ingredients is a trade secret.

Section III - Physical/Chemical Characteristics: This section should include information on boiling point, vapor pressure, vapor density, solubility in water, specific gravity, percent volatile, evaporation rate, appearance, and odor. Sometimes the pH is included for aqueous solutions.

Some of this information can be helpful in determining how much will evaporate and how fast. This is especially useful for products containing organic solvents. The percent volatile, for example, can tell you how much can evaporate. The evaporation rate will give you an idea of how long it will take to evaporate. Unfortunately, different manufacturers use different standards, but, in general, low numbers mean it takes longer to evaporate.

Section IV - Fire and Explosion Hazard Data: This section has information on the flammability of the product (e.g., flash point, and upper and lower flammability limits), on types of fire extinguishers needed, and on other special precautions. There data are important when planning for emergencies. See Chapter 24 for more information on flammability.

Section V - Reactivity Data: This section is very important if you might heat the product, mix it with other chemicals, expose it to ultraviolet radiation, etc. It tells you about the product's compatibility with other chemicals, and special conditions to avoid. The stability of the product indicates whether the product can decompose and what conditions can cause this. For example, potassium ferricyanide (Farmer's reducer) can decompose to release hydrogen cyanide gas if heated, exposed to ultraviolet radiation, or if acid is added.

The incompatibility section tells you what chemicals can react with the product. For example, chlorine bleach is incompatible with ammonia since they react to produce a poison gas. This section is very important in determining what materials you should not store near this product.

Hazardous decomposition products tells you what hazardous chemicals can be produced when the product is heated or burned. For example, when you heat or burn Plexiglas, you can produce the irritant methyl methacrylate.

The hazardous polymerization section tells you whether the product can polymerize, and what conditions can cause this.

Section VI - Health Hazard Data: This section should tell you the routes (skin contact, inhalation, ingestion) by which the product can affect you, the symptoms of overexposure, acute and chronic health effects, emergency first aid measures, and carcinogenicity.

If the product, or chemicals in the product, has been found to be a carcinogen or probable carcinogen by the International Agency for Research on Cancer or OSHA, or is listed in the National Toxicology Program's *Annual Report on Carcinogens,* then the MSDS must state so.

The MSDS should also list medical conditions which could be aggravated by exposure to the product.

Section VII - Precautions for Safe Handling and Use: This section covers such topics as spill control, waste disposal, storage and

handling precautions, and other special precautions such as personal protective equipment needed for spills. Unfortunately, the section on waste disposal often just says dispose of according to local, state, and federal regulations. Precautions are discussed in detail in subsequent chapters.

Section VIII - Control Measures: This section should give you a lot of information about respirators, ventilation, and other personal protective equipment, but it often doesn't.

The respirator recommendations should state what type of cartridge should be used. The ventilation section should tell you whether general mechanical ventilation (dilution ventilation) is sufficient, or if local exhaust ventilation is recommended, and if so, what type. This section should also list other recommended personal protective equipment such as gloves, goggles, and protective clothing. Unfortunately, most MSDSs do not tell you what type of glove to use.

REFERENCE SOURCES

The Bibliography at the end of this book lists a number of references where you can obtain additional information on the hazards of chemicals found in art materials.

21

▲

SUBSTITUTION OF SAFER
MATERIALS AND PROCESSES

Use the safest materials possible. In many instances you can substitute a less toxic material for a more hazardous one without sacrificing quality. Examples are using cadmium-free silver solders to replace cadmium-containing ones; using glass beads, silicon carbide, or aluminum oxide to replace silica sands in abrasive blasting; using titanium white or zinc white to replace lead white (flake white) pigments; and using lead-free glazes and enamels.

Solvents are another area in which substitution can result in a safer work environment. As discussed in Chapter 4, solvents have a wide range of toxicity, and, often, highly toxic solvents can be replaced with less toxic solvents. For example, xylene or lacquer thinners, often used for cleaning silk screens, can usually be replaced with the less toxic mineral spirits (or mineral spirits with about 15 percent added toluene or xylene for hard spots). Chlorinated solvents like trichloroethylene and perchloroethylene can sometimes be replaced by mineral spirits. Lacquer thinner can often be replaced with acetone, which is only slightly toxic (although it is extremely flammable). Methyl alcohol can almost always be replaced by denatured alcohol or isopropyl alcohol. In fact, the least toxic solvents you can use are acetone, denatured alcohol, isopropyl alcohol, and mineral spirits (especially the odorless paint thinners that have the aromatic hydrocarbons removed).

Another type of substitution is to use water-based materials instead of those that are solvent-based. This can be particularly im-

portant for schools. Examples are using water-based silk-screen inks, water-based contact cements, and water-based felt-tip markers. Water-based paints such as water color and acrylics would, for example, be safer to use during pregnancy than oil paints requiring turpentine or mineral spirits.

Process changes can also often result in safer procedures. Working with wet processes or materials is much better than working with powders. For example, wet clay or water-based dyes can be purchased instead of dry clay or powdered dyes. Wet grinding techniques can often be used instead of dry grinding. Another example of a process change is to apply paints, finishes, glazes, and the like by brushing or dipping instead of spraying or air brushing.

Finally, chemicals that can cause cancer should be replaced. The level of precautions needed to work safely with carcinogens is much more stringent and costly than those required for ordinary toxic chemicals. The main reason for this is that there is no known safe level of exposure to cancer-causing chemicals and therefore exposure should ideally be zero. Examples of carcinogens that should be avoided include asbestos, cadmium fumes, lead and zinc chromate, uranium oxide, benzene, and pentachlorophenol.

One warning about using substitutes. Always make sure the substitute isn't more hazardous than the original, and allow sufficient time to learn how to use the substitute. Substitutes are usually different chemicals with different properties. You have to learn the peculiarities of the substitute. For example, you can not paint with acrylics in the same manner as you do with oils.

22

▲

VENTILATION

Ventilation is one of the most important—and most neglected—factors in designing a studio. Ventilation should always be tried before considering respiratory protection. The problem is the definition of adequate ventilation. Many people think that an open door or window or an air conditioner is adequate ventilation. It isn't. You have no control over wind direction with an open window and it does not provide sufficient air movement. The problem with an air conditioner is that it recirculates almost all the air—even on "vent," and does not exhaust any contaminants.

There are two basic types of ventilation: dilution ventilation and local exhaust ventilation. Dilution ventilation involves bringing in clean, outside air to dilute any contaminants to a safe level and then exhausting it to the outside. Local exhaust ventilation involves capturing the toxic contaminants at their source and exhausting them before they get into the air you breathe.

DILUTION VENTILATION

Dilution ventilation is only effective with small amounts of slightly or moderately toxic solvents and gases. Large amounts of solvent vapors or highly toxic solvent vapors would require enormous amounts of air to dilute them, which would be expensive in terms of both fans and energy costs required to heat or cool the incoming air. Dilution ventilation is not effective with dusts because it stirs them up.

In designing a dilution ventilation system, there are several factors to consider. First, make sure there is adequate make-up air to replace the air being exhausted. Second, make sure that the

exhaust fan is located so that clean air passes your face before being contaminated and exhausted. Third, make sure that exhaust outlets and air intakes are located far enough apart so that the contaminated exhaust air cannot reenter the room.

The actual size of the fan needed to dilute the contaminants to a safe level depends on the toxicity of the material, and the amount of material escaping into the room in a given time period. Chapter 5 of *Ventilation* (see Bibliography) discusses how to calculate the needed dilution ventilation rate.

For example, an oil painter using less than 1/2 cup of turpentine or paint thinner over a period of four hours would only need a fan exhausting about 250 cubic feet per minute. This could be achieved with a simple window-exhaust fan and by setting up the easel about three feet away from the window.

LOCAL EXHAUST VENTILATION

Local exhaust ventilation should be used for such processes as silk-screen printing and cleanup, acid etching, spraying operations, welding, kiln firings, woodworking operations, clay mixing, photographic toning, and the like.

Local exhaust systems consist of a hood to capture the contaminants, ducts to carry the contaminated air to the outside, an exhaust fan, and sometimes dust collectors to remove dust from the exhausted air. (See Figure 1.) In general, local exhaust ventilation is preferred over dilution ventilation because it is more effective, uses less air and therefore has lower ongoing energy costs, and does not expose people to the contaminants even at low levels.

Figure 2 shows a variety of common types of hoods. These are a spray booth, a slot hood, a canopy hood, a movable exhaust, and a dust-collecting hood.

A general rule is that the more you enclose the process the better, as shown with the spray booth and the flanges on the movable exhaust for welding.

The hood should be located so that the natural velocity of the contaminant will be in the direction of the hood opening. For example, spray booths exhaust at the rear or top rear because that is the direction of the spraying. Similarly, canopy or overhead hoods are used to capture hot, rising gases from kilns and furnaces. A canopy hood should not be used in situations where you would

Figure 1

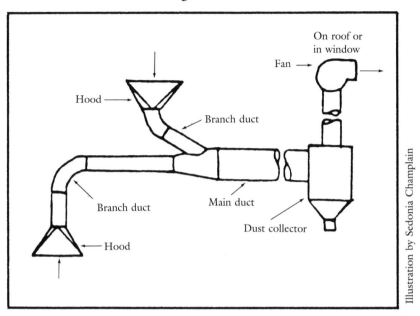

Typical local exhaust system: hood, collector, and fan
(Adapted from a PHILAPOSH factsheet)

have your head under the hood because that would place your head in the upward stream of contaminants.

The hood should be placed as close to the source of the contaminant as possible. Otherwise, the contaminants might escape before the hood can capture them. For example, movable exhausts for welding are best used four to six inches from the point of welding, and slot hoods used in silk-screen printing, for example, are usually only effective over a distance less than three feet.

Of course, make sure that there is an adequate supply of replacement air and that the exhausted air cannot reenter the room.

Ducts should be made of materials that won't be affected by the contaminant. To keep air flowing smoothly, ducts should be circular, with as few bends as possible, and the bends should be gradual, not abrupt. With dusts, the duct velocity must usually be at least 3,500 feet per minute to keep the dust from settling in the duct.

There are two basic types of fans: axial or propeller fans, and centrifugal fans (see Figure 3). Propeller fans are used for dilution ventilation, while centrifugal fans are used for most other types

Figure 2 Hoods for local exhaust ventilation sytems

Local Exhaust Ventilation for Art and Craft Processes

CANOPY HOOD

Process: ceramic kiln, metal foundry, forging.
Form: vapor, gas, fume, steam.
Not ready made.*

Advantages
Captures upward-moving contaminants.
Good for heat-producing operations.
Handles surges of hot air.
Easy to construct.
Designed in various sizes.
Disadvantages
Exposes worker to contaminants if he works under hood.
 Often used improperly.
Should not be used for dust.

SLOT HOOD

Process; silkscreening, acid etching, bench welding, soldering.
Form: vapor, gas, fume.
Not ready made.*

Advantages
Has universal applications.
Does not interfere with most processes.
Can cover a long work area: four-foot maximum selections
 are used side by side.
Good for processes performed on a work bench.
Disadvantages
Work must be kept in close proximity of slot opening.
Work-table depth has a 36" maximum.
Can be difficult and costly to construct.

SPRAY BOOTH
and other enclosed hoods

Process: spraying laquer, paint, ceramic glazes, flammable materials, highly toxic materials.
Form: vapor, gas, fume, dust.
Ready made.*

Advantages
Completely encloses contaminant.
Safest hood for flammables and highly toxic materials.
Conserves materials.
Reduces housekeeping.
Designed in various sizes.
Disadvantages
Cost of operation high.
Requires more space than other hoods.
Requires constant cleaning.

**PLAIN-
OPENING
HOOD**

Process: welding, soldering, art conservation.
Form: vapor, gas fume.
Ready made.*

Advantages
Can be used in areas where conventional hood will
 not fit.
Can be connected to flexible ducting for repositioning to
 fit work and for several alternating locations.
Easy and inexpensive to construct.
Disadvantages
Must be in a range of four to six inches from opening
 for effective capture.

**DUST-
COLLECTING
HOOD**

Process: grinding, woodworking, polishing.
Form: dust.
Sometimes ready made.*

Advantages
Reduces housekeeping.
Reduces fire hazards.
Disadvantages
Ready-made hoods often ineffective.
Requires constant cleaning.

* Ready-made hoods are available in set sizes and are complete with all equipment from manufacturer and dealers. Others must be fabricated by a sheet-metal shop.

First appeared in *Ventilation: A Practical Guide,* Center for Occupational Hazards, 1984

Illustration by Sedonia Champlain

Figure 3

Axial Flow

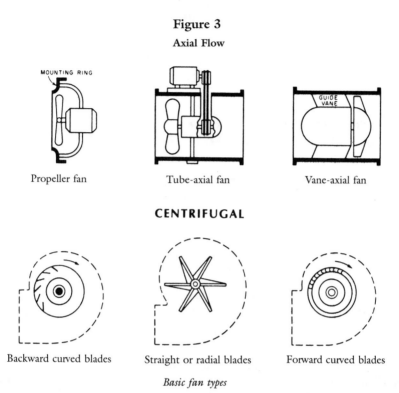

Propeller fan Tube-axial fan Vane-axial fan

CENTRIFUGAL

Backward curved blades Straight or radial blades Forward curved blades

Basic fan types

of ventilation. If the gases, vapors, or dusts being exhausted are flammable, then explosion-proof systems are required.

More detailed information on ventilating studios can be found in *Ventilation* (see Bibliography).

23

▲

STORAGE, HANDLING, AND HOUSEKEEPING

STORAGE

Safe storage of art materials involves simple steps. First, choose appropriate containers. Never store solvents or other chemicals in unmarked containers or food and drink containers like those used for milk, orange juice, and so forth, because of the risk that a child—or even you—might drink the contents by mistake. Avoid breakable glass containers whenever possible. Dyes and other materials that come in small paper bags should be transferred to plastic containers to avoid tears in bags that will release dust into the air. Clay and glaze chemicals in large 100-pound paper bags with rips in the bag should be used immediately or the whole bag placed in a plastic garbage bag. All containers should be labeled.

Second, make sure materials will not fall off shelves. Restraining strips along the shelves can help prevent this. In addition, acids and other corrosive chemicals should not be stored on high shelves because of the danger of the container falling and breaking and splashing the chemical all over the work area.

Third, do not store together chemicals that can react with each other. For example, photographic fixing solutions and acids should not be stored next to each other because, in case of an accident resulting in the mixing of the two chemicals, large amounts of irritating sulfur dioxide gas would be produced. Peroxide hardeners used with plastics resins should be stored separately

from organic chemicals because they could react explosively with each other. Material Safety Data Sheets describe the chemical incompatibilities of their products.

HANDLING

Keep all containers covered to prevent evaporation of solvents, even if you are using them for only a few minutes. Self-closing containers are best. Solvent-containing cans with paint brushes in them can be covered with aluminum foil.

Powders should be handled in such a way as to minimize dust escaping into the air. Containers should be kept closed. When pouring powders, do so carefully. In many instances, powders can be mixed in a simple, enclosed glove box as shown in Figure 4. The box can be made of cardboard and sealed inside with shellac or similar sealant to make it easier to clean. The purpose of the glove box is to prevent dust from escaping.

Always dilute concentrated acids by adding the acid to the water, never the reverse, to prevent the acid from splashing into your face.

Figure 4

Enclosure for mixing powders

Personal work practices can also help achieve a safer environment. Do not eat, drink, or smoke in the work area and wash your hands after work. Do not use turpentine or other solvents to clean your hands but use soap and water or a safe waterless hand cleanser (obtained from a safety-supply house). Keep separate work clothes and change them before leaving the studio or entering living areas. Wash them separately from other clothes.

In case of splashes on the skin, rinse with lots of water. If you are using concentrated acids or other corrosive materials, you should have quick access to an emergency shower.

In case of splashes in the eyes, rinse with lukewarm water for at least fifteen minutes and then contact a physician. An eyewash fountain that does not require your hands to operate it is recommended. A piece of rubber hose attached to a tap can be an interim solution. It should be held vertically so that water bubbles out of the hose end. Contact lenses should not be worn in situations where chemicals can splash in the eyes.

HOUSEKEEPING

If you live and work in the same area, the risk of contaminating living areas becomes greater. You should never work in your kitchen or living areas, but should set aside a separate area just for work. In particular, keep children away from your work area.

One of the biggest problems in housekeeping is dust control. Dust should always be wet-mopped or vacuumed, never swept. Sweeping just stirs up the dust. Highly toxic dusts like clay dust, asbestos, and lead dust require a special HEPA vacuum cleaner because very fine dusts go right through normal industrial vacuum cleaners. Work surfaces should be wet-mopped daily.

Spills should be cleaned up immediately to prevent evaporation of volatile liquids or the spreading of dust. For large toxic and/or flammable liquid spills, do not try to clean them up yourself because of fire and health risks. Shut off flames, evacuate the area, shut off the power from outside the room, and call the fire department. For small spills, use spill control materials.

Dispose of waste art materials safely. Disposal of large quantities of hazardous chemicals should be done by a waste-disposal service. Substitution, evaporation, neutralization, and recycling are other waste management options.

Sometimes the chemistry department of a nearby university or high school can help you. Do not pour waste solvents down the sink because of the risk of fire hazards, evaporation from drains in other rooms, and contamination of water. Some artists have poisoned their septic-tank system by pouring hazardous chemicals down the drain. Small quantities of volatile solvents (less than a pint) can be disposed of by allowing them to evaporate under a hood or outside.

If local codes allow, nonhazardous aqueous solutions can be poured down the sink. However, this should be done one at a time with lots of water. Acids and alkalis should be neutralized first.

See references for more information on spill control and disposal of art materials.

24

▲

FIRE PREVENTION

The storage and handling of flammable materials is regulated strictly by your local fire department. Art materials that are fire and explosion hazards include flammable and combustible solvents, organic dusts like rosin dust, cylinders of compressed gases for welding, and strong oxidizing agents like peroxide hardeners and potassium permanganate.

FLAMMABLE AND COMBUSTIBLE LIQUIDS

The flammability of a solvent is characterized by its flash point, the lowest temperature at which a liquid gives off enough vapors to form an ignitable mixture with air. If a source of ignition—flame, lit cigarette, spark, hot surface, or static electricity—is present, then a fire can result.

The lower flammable (or explosive) and upper flammable (or explosive) limits of a liquid are the minimum and maximum concentrations of liquid vapors in the air required for the liquid to catch fire if a source of ignition is present. Below the lower flammable limit, the mixture is too "lean" (not enough fuel), and above the upper flammable limit, the mixture is too "rich" (not enough oxygen).

The National Fire Protection Association (NFPA) classifies liquids as flammable if their flash point is under 100°F, and as combustible if their flash point is at or above 100°F. Flammable liquids can easily catch fire on a hot day or even at room temperature. The NFPA further classifies flammable liquids into Classes IA, IB, and IC, and combustible liquids into Classes II and III. Table 2

TABLE 2 NFPA Flammability and Combustibility Definitions		
FLAMMABLE LIQUIDS		
CLASS IA *Flash point: below 73° F (23° C)* *Boiling point: over 100° F (38° C)*	Ethyl ether "Flammable" aerosol sprays	
CLASS IB: *Flash point: below 73° F (23° C)* *Boiling point: over 100° F (38° C)*	Acetone Benzine (VM&P naphtha) Benzol (benzene) Butyl acetate Cyclohexane Dioxane Ethyl acetate Ethyl alcohol	Ethylene dichloride Gasoline Heptane Hexane Isopropyl alcohol Methyl acetate Methyl alcohol Methyl ethyl ketone Toluene (toluol)
CLASS IC *Flash point: 73–100° F (23–38° C)* *Boiling point: over 100° F (38° C)*	Amyl acetate Amyl alcohol Butyl alcohol Methyl butyl ketone Methyl isobutyl ketone n-Propyl alcohol Styrene Trichloroethylene Turpentine Xylene (xylol)	

shows the flammability classifications of many common solvents. Mixtures of solvents are often as flammable as the most flammable component since one component catching fire can then set off the others in the mixture. Heating a combustible liquid can convert it into a fire hazard since you might reach its flash point.

The Consumer Product Safety Commission (CPSC) uses a different classification system, defined by the Federal Hazardous Substances Act. According to the Act, a liquid is extremely flammable if its flash point is below 20°F, is flammable if its flash point is between 20°F and 80°F, and is combustible if its flash point is between 80°F and 150°F. The main difference between the two

TABLE 2 (continued)		
COMBUSTIBLE LIQUIDS		
CLASS II *Flash point: 100–140°F* *(38–60°C*	Cellosolve acetate Cyclohexanone Dimethyl formamide Ethyl silicate Isoamyl alcohol Kerosene Methyl cellosolve Mineral spirits (odorless paint thinner)	
CLASS IIIA *Flash point: 140–200°F* *(60–93°C)*	Butyl cellosolve	
CLASS IIIB *Flash point: over 200°F* *(93°C)*	Cellosolve Diethylene glycol Ethylene glycol Hexylene glycol	

Source: Michael McCann. *Artist Beware* (New York: Lyons & Burford, 1992)
Reproduced by permission of the publisher.

classification systems is that the NFPA defines liquids with flash points between 80°F and 100°F as flammable, whereas the CPSC defines them as combustible. The NFPA system is more protective since liquids with flash points between 80°F and 100°F could catch fire easily on a hot day.

Flammable liquids need particular care. More than one quart of solvent should be stored in approved safety containers. Large quantities of flammable and combustible liquids should be stored in capped flammable storage cabinets. Note that flammable storage cabinets are intended to prevent their contents from catching fire for at least ten minutes in order to allow room occupants time to escape. Waste solvents should be stored in solvent disposal containers, and solvent-soaked rags stored in proper oily waste disposal containers.

Purchase in as small a quantity as possible to limit the amount of flammable liquids present. Do not allow smoking in any studio containing flammable or combustible liquids. Eliminate all other sources of ignition such as flames, sparks, static electricity, hot

metal surfaces, electric elements, etc. When pouring flammable liquids from large metal drums into metal containers, connect the two metal containers together with wire to bond them to prevent the buildup of static electricity, and ground the metal drum with a ground wire leading to a ground such as a tap or radiator. In areas in which large amounts of flammable liquids are used, all wiring and equipment should meet standards of the NFPA's National Electrical Code. Clean up spills of flammable liquids immediately.

OTHER FIRE HAZARDS

Flammable and Combustible Solids: Many solids are combustible and can create fire or explosive hazards if proper precautions are not taken to prevent sparks, static electricity or other sources of ignition. Explosive hazards can result from dusts that can form explosive mixtures with air. Examples include: finely divided dusts of combustible solids such as carbon, rosin, wood, and plastics; and metal powders such as aluminum, zinc, magnesium, and iron. A lesser fire hazard is due to coarse dusts that may burn rapidly but do not form explosive mixtures with air. These include solid fibers and shredded materials such as cotton and hemp, which can create flash fires in the presence of an ignition source.

Precautions include eliminating sources of sparks, flames, lit cigarettes and other sources of ignition, and carefully wet mopping or vacuuming explosive dusts and other combustible solids and storing them in approved self-closing, noncombustible waste cans. Only use vacuum cleaners approved for combustible dusts.

Spontaneous Combustion: Linseed oil, tung oil, and other organic oils slowly oxidize in air and release heat. Rags and paper towels soaked with these oils can spontaneously catch fire if the heat cannot dissipate and builds up. This is particularly a hazard when oily rags are placed in piles where the heat cannot dissipate.

Precautions include storing oil-soaked rags in approved oily waste cans that allow air to circulate around the can to dissipate heat. Do not put plastic liners in these containers since that will prevent the heat from dissipating. Empty daily. Alternatives are to hang the oily rags separately, or place them in a pail of water.

Oxidizing Agents: Oxidizing agents, or oxidizers, can react with organic solvents, combustible materials (e.g., wood dust, paper, cloth, etc.) and other organic materials to cause fires or explosions.

Common examples of strong oxidizing agents are chlorates, dichromates, chromates, concentrated hydrogen peroxide, nitrates, and concentrated nitric acid. Organic peroxides, such as methyl ethyl ketone peroxide, can catch fire if heated.

Precautions include storing oxidizing agents away from solvents, paper, wood dust, and other combustible materials, and other organic compounds.

Compressed Gases: Compressed flammable gases include acetylene and liquified petroleum gases used in silver soldering and welding processes. Compressed oxygen cylinders are also a hazard, since, while oxygen itself is not flammable, it supports combustion and can make combustible materials burn much more readily.

Store oxygen cylinders at least 20 feet from fuel cylinders or other flammable materials such as paints, solvents or oil, or separate by a 5-foot high wall with a fire-resistance rating of at least a half hour. Do not store them near high traffic areas. Ventilate indoor storage areas. Keep cylinders away from all sources of sparks, electric arcs, open flames, direct sunlight, and other sources of heat. Secure all cylinders upright with chains or other fasteners. Keep cylinders in carts designed for them. Transport these cylinders upright in carts. Ensure that grease or oil cannot come in contact with the cylinders, especially near the nozzle or valve, in order to protect against fire. You should always refer to manufacturers' operating manuals for compressed gases and regulators.

FIRE EXTINGUISHERS

Your studio should have the proper type of fire extinguisher. Class A fire extinguishers are good only for fire involving normal combustibles like paper and wood. Solvent or grease fires need Class B fire extinguishers, and electrical fires need Class C fire extinguishers. If you have all three types of fire hazards present, then you need a Class ABC multipurpose dry chemical fire extinguisher. If there is no Class I fire hazard, then a Class BC carbon dioxide fire extinguisher is adequate.

The fire extinguisher should be located near exits and near (but not too close) to major fire hazards. The fire extinguisher should be readily visible, and not obstructed in any way. You should have training in the use of your fire extinguisher.

More detailed information on fire prevention can be found in the references in the Bibliography.

25

▲

PERSONAL PROTECTIVE

EQUIPMENT

Personal protective equipment, especially respirators, should be considered a last resort after substitution, ventilation, and other protective measures have not worked. Personal protective equipment can be uncomfortable and not fit properly, interfere with communication, not provide complete protection, and only protect the person wearing it.

GLOVES

There are many different types of gloves for different purposes. For protection against high heat, use leather, woven fiberglass, or similar materials. Do not use asbestos gloves because studies have shown they can give off large amounts of asbestos fibers into the air.

For protection against liquids, there is a variety of rubber and plastic gloves. However, you have to match the glove to the liquid, since many liquids can penetrate different glove materials. Table 3 gives some recommendations for glove selection.

Most gloves do not provide good protection against chlorinated hydrocarbons and paint and varnish removers. The thicker the glove, of course, the better the protection. The life of a glove depends on a variety of conditions, including length of contact with the chemical, temperature, concentration of liquid, and physical wear and tear. For example, your gloves will last longer when used with solvent-soaked rags than when used pure liquid solutions. You

TABLE 3 GLOVE SELECTION	
Acids (dilute)	any type of rubber or plastic glove
Acids (concentrated)	neoprene, latex/neoprene, butyl rubber
Alkalis	any type of rubber or plastic glove
Alcohols	any type of rubber or plastic glove
Aromatic hydrocarbons	BUNA-N or NBR rubber nitrile
Chlorinated hydrocarbons	nitrile, or NBR rubber
Glycol ethers	neoprene or nitrile
Ketones	natural, neoprene, or butyl rubber
Petroleum distillates	neoprene or NBR rubber, nitrile
Turpentine	neoprene or NBR rubber, nitrile

can also prolong the life of your gloves by washing them with soap and water before removing them and then allowing them to air dry. Cotton liners can help prevent dermatitis.

If gloves are not practical, then the use of barrier creams will provide some protection by placing an impermeable barrier between your skin and the chemicals. There are two basic types of barrier creams: water-insoluble and solvent-insoluble. These barrier creams have to be renewed several times a day.

FACE AND EYE PROTECTION

The face and eyes must be protected against a variety of hazards, including impact (chipping, grinding, and so forth), radiation (such as infrared from kilns, glassblowing, welding, foundry; ultraviolet radiation from arc welding, carbon arcs), and chemical splash (from acids, caustics, solvents and the like). Face shields are intended only to protect the face against damage; they do not provide adequate eye protection. Goggles should be worn under face shields. In most instances, only the eyes need protecting and goggles should be worn. All face and eye protection should meet the standards of the American National Standards Institute's *Practice for Occupational and Educational Eye and Face Protection* (ANSI Z87.1).

Protection against impact can involve use of spectacles with impact-resistant lenses and side shields, flexible or cushioned goggles, and chipping or eyecup goggles. The spectacles with side shields are the least useful. Goggles are available that can be worn with glasses; and goggles can be obtained with prescription lenses.

Protection against infrared radiation requires infrared goggles or goggles with shade ratings between 2 and 3. Various welding goggles with different shade numbers are available, depending on the intensity of the ultraviolet radiation. For arc welding, face shields are also needed.

Protection against chemical splash depends on the severity of the potential exposure. For working with hot, concentrated acids, either face shields with goggles or complete hoods covering the head and shoulders are available. For other situations, chemical goggles with baffled ventilation are available. If the gases are eye irritants, you might need goggles without ventilation.

HEARING PROTECTORS

Excessive noise over a period of years can cause hearing loss. In addition, heart disease, gastrointestinal disorders, allergies, and similar ailments have been linked to excessive noise. A rule of thumb is that if you have to raise your voice to be heard one to two feet away, then you have a noise hazard.

Noise levels are measured in decibels (dB) on the logarithmic scale; every increase of 10 dB means the noise intensity has increased tenfold. Table 4 lists the noise levels of some common activities.

The Occupational Safety and Health Administration (OSHA) has set a maximum permissible noise level of 90 dB for an eight-hour day and a ceiling of 115 dB. Even this level, however, could cause hearing loss in about 20 percent of the population.

If noise-control measures such as isolation, proper maintenance, silencers, mufflers, vibration isolators (shock absorbers), or quieter machines are not practical or do not work, then you will have to wear ear plugs or ear muffs. Ear plugs come in a variety of sizes and types. Some of the new foam ear plugs are almost as good as ear muffs. The use of improvised materials like wax or cotton is not recommended; they may themselves be harmful.

RESPIRATORS

The Occupational Safety and Health Act of 1970 states that respirators are allowed only for emergency use, when engineering controls (e.g., ventilation) are not feasible, or as a temporary measure while engineering controls are installed. Further, OSHA requires a

TABLE 4	
Noise Levels of Common Activities	
discotheque	115 dB
woodshop	110 dB
circular saw	100–109 dB
foundry	90–99 dB
machine shop	80–89 dB
spraying	80–89 dB
ordinary conversation	60 dB

written respirator program if respirators are used. This respirator program includes information on such matters as respirator selection, fit testing, cleaning, storage, and inspection. It also requires a medical examination for anyone wearing a respirator because the extra breathing strain caused by respirator resistance to air can be hazardous to people with certain heart, lung, and other problems. These same rules are useful for anyone wearing a respirator.

Respirators come in two basic types: air-supplying and air-purifying. Air-supplying respirators provide a source of uncontaminated air for a person to breathe. The air can come from a self-contained breathing apparatus (SCBA), from separate tanks of breathable compressed air, or from an air compressor. This type of respirator is expensive, and requires considerable training in safe use. It is needed only in cases of oxygen deficiency or with chemicals that are immediately harmful to life or health. Artists should carefully review their materials and processes and consider substitution or ventilation before considering air-supplying respirators.

Air-purifying respirators, on the other hand, remove the toxic chemicals from the air you are breathing. The air-purifying respirator consists of two basic parts, the facepiece and the cartridge, canister, or filter that removes the contaminant. The facepiece can be full face, giving the eyes protection against eye irritants; half face, which covers mouth, nose, and chin; or quarter face, which only covers the mouth and nose. Nowadays, respirator facepieces often come in several sizes and will fit women and others with small faces. In addition, there are disposable respirators that combine the filter and facepiece. These do not provide as much protection as the standard type.

Different cartridges and filters are available to remove different contaminants. Filters to remove particulates can be for dusts and mists to remove dusts and particulate mists, or for dusts, mists, and fumes to remove welding metal fumes. High-efficiency filters are also available for radioactive dusts, and extremely toxic dusts such as asbestos, lead, and cadmium. You replace the filters when they become difficult to breathe through.

There are three basic types of cartridges: organic vapor, to remove solvent vapors, polyester resin vapors, and the like; ammonia; and acid gas to remove chlorine, hydrochloric acid gas, and sulfur dioxide. Combinations of different types of cartridges (and of cartridges and filters) are also available.

Since the purifying chemicals in cartridges get used up, eventually the vapors or gases start to pass through the cartridge. The time this takes depends on the frequency and length of exposure, and on the concentration of the contaminant. Even water vapor can use up the purifying chemicals. A general rule of thumb is that cartridges should be changed after 10 days, after eight hours of cumulative use, or if the contaminant can be smelled. For this reason, you should not use a respirator with chemicals that have poor odor warning. These include methyl alcohol, nitrogen dioxide (from acid etching), isocyanates from polyurethane resins, and carbon monoxide.

In choosing a respirator there are several important factors to take into account. First, the respirator must be approved by the National Institute for Occupational Safety and Health (NIOSH). Do not use "nuisance dust" or "non-toxic dust" masks for protection against toxic materials.

Second, make sure the respirator fits properly and comfortably. If it doesn't, air will take the path of least resistance and leak in around the edges. People with beards, unusually shaped faces, scars, and the like will not be able to get an adequate fit. To make a simple negative-pressure fit test, block the air inlets, inhale, and hold your breath about 20 seconds. The respirator facepiece should collapse around your face due to the negative pressure inside the respirator. If it does not collapse or goes back to normal, your facepiece does not fit. Try another model and make until you find one that does.

Respirators should be regularly checked for damage and cleaned (and disinfected if more than one person uses it—a practice

I do not recommend). One recommended cleaning procedure consists of (1) removing cartridges and filters, (2) washing the facepiece and any tubing with soap and water using a handbrush, (3) rinsing completely in warm water, (4) air-drying in a clean area, (5) cleaning other parts as recommended by the manufacturer, and (6) inspecting the respirator for damage. After this is completed, the respirator should be reassembled and stored in a plastic bag or container away from chemicals, dust, light, and heat.

See the Bibliography for more detailed references on respirators.

OTHER PROTECTIVE CLOTHING AND EQUIPMENT

A wide variety of personal protective clothing and equipment is available besides those discussed so far. These include leather aprons or clothing for heat protection, protective leggings and sleeves, hard hats, safety shoes, hair nets, and others. You should obtain a safety-supply catalogue from a safety-equipment distributor to discover what is available.

26

▲

HOW TO GET HELP

MEDICAL HELP

If you are having symptoms that only appear when you are working or a few hours later, and tend to dissipate when you are away from work for several days, then they might be related to overexposure to your art materials. The illness might be caused directly by the art materials, or the art materials may be exacerbating a medical problem you already have. In either case you should see a doctor.

You should tell your doctor what materials you are working with and any information you have about the effects of these chemicals. Sometimes you can help pinpoint the specific chemical causing a problem by keeping a log of what materials you are using when the symptoms appear.

One problem may be finding a doctor who is knowledgeable about the toxic effects of chemicals or who will listen to you when you say your symptoms may be caused by exposure to your art materials. Most physicians have no training in the toxic effects of chemicals and even fewer are knowledgeable about art materials. If your physician will not listen to you, find one who will.

Often you may need a referral to a physician who is an expert in occupational medicine. Appendix 1 is a list of occupational health clinics around the United States and Canada that have physicians with this expertise.

Even if you are not having symptoms, you might want to have a checkup to see if your art materials are harming you. Most medical-surveillance tests check for damage to body organs and do not test for the presence of chemicals. The major exception is lead,

and anyone exposed to lead should have regular blood lead tests. Other common medical-surveillance tests include lung-function tests and sometimes chest x-rays if you are exposed to dusts or respiratory irritants, liver- and kidney-function tests if you are exposed to solvents and other chemicals affecting these organs, and audiograms if you are exposed to excessive noise. In many instances, you should get a baseline test now, and then repeat the test every few years to see if there is any change.

SOURCES OF SAFETY EQUIPMENT

Appendix 2 lists suppliers of respirators and other safety equipment. Most major cities have distributors of safety equipment. You should check the Yellow Pages under safety equipment for the nearest one.

FOR FURTHER INFORMATION

The Center for Safety in the Arts is a national resource center for research and education on the hazards of art and craft materials. If you have questions on art hazards or need help, you can write or telephone the Art Hazards Information Center. CSA has over 100 publications—including books, pamphlets, articles, and data sheets—on art hazards. Send a self-addressed, stamped, legal-sized envelope for a copy of our publications list. CSA also publishes the *Art Hazards News,* has a lecture and consultation program, and offers courses on art hazards. The address is: Center for Safety in the Arts, 5 Beekman Street, New York, NY 10038. Telephone (212) 227–6220.

Other possible sources of help on art hazards are your local American Lung Association, regional offices of the National Institute for Occupational Safety and Health (NIOSH) and, in Canada, the Canadian Center for Occupational Health and Safety in Hamilton.

The Bibliography lists general references on occupational health and specific references on art hazards.

APPENDICES

▲

APPENDIX 1
Occupational Health Clinics - 1993

This list was prepared by the Center for Safety in the Arts with help from the Association of Occupational and Environmental Clinics (AOEC).

ALABAMA

UAB Occupational Medicine
 Services
930 20th St
South Birmingham, AL 35205
(205) 934-7303

ARIZONA

HELIAM Occupational
4600 South Park, Suite 5
Tucson, AZ 85714
(602) 889-9574

HELIAM Occupational
2545 East Adams
Tucson, AZ 85716
(602) 881-0050

Family Annex
School of Medicine
University of Arizona
1450 N Cherry Avenue
Tucson, AZ 85719
(602) 626-7900

CALIFORNIA

Irvine Occupational Health
 Center
University of California at Irvine
19722 MacArthur Blvd.

Irvine, CA 92715
(714) 856-8640

Occupational Health Center
 Barlow Hospital
6331 Greenleaf Ave, Suite B
Whittier, CA 90601-3553
(310) 907-4570

Occupational and Environmental
 Medicine Clinic
University of California/Davis
4301 X Street
Sacramento, CA 95817
(916) 734-27155

Occupational Health Clinic
San Francisco General Hospital,
 Building 9
1001 Potrero Avenue, Room 109
San Francisco, CA 94110
(415) 206-5391

Occupational and Environmental
 Medicine Clinic
University of California/San
 Francisco
400 Parnassus, A-585, Box 0322
San Franscico, CA 94143
(415) 476-1841

COLORADO

Occupational and Environmental
 Medical Division
National Jewish Center
1400 Jackson Street
Denver, CO 80206
(303) 398-1520

CONNECTICUT

New Haven Occupational
 Medical Program
Yale University
333 Cedar St, Box 3333
New Haven, CT 06510
(203) 785-5885

University of Connecticut
 Occupational Medicine
 Program
263 Farmington Avenue
Farmington, CT 06030
(203) 679-2366

Lawrence and Memorial
 Occupational Health Center
404 Thames St, Suite 2B
Groton, CT 06340
(203) 445-4551

DISTRICT OF COLUMBIA

Division of Occupational and
 Environmental Medicine
George Washington University
2300 K Street, NW, Suite 201
Washington, DC 20037
(202) 994-1734

GEORGIA

Emory University
 School of Public Health
Division of Occupational and
 Environmental Health

1599 Clifton Road, NE
Atlanta, GA 30329
(404) 727-3697

HAWAII

Occupational Medicine
Straub Main Clinic and Hospital
888 South King Street
Honolulu, HI 96813
(808) 522-4321

ILLINOIS

Bridgeview Internal Medicine
 Clinic
7020 West 79th Street
Bridgeview, IL 60455
(708) 599-8200

JOBMED
St. Mary's Hospital
2233 West Division
Chicago, IL 60622
(312) 770-3275

Division of Occupational
 Medicine
720 South Wolcott
Cook County Hospital
Chicago, IL 60612
(312) 633-5310

Managed Care Occupational
 Health Program
Mt. Sinai Hospital
2720 West 15 Street
Kling Building, Room 534
Chicago, IL 60608
(312) 650-6480

University of Illinois
 Occupational Medicine
 Program
840 South Wood
Chicago, IL 60612
(312) 996-2592

IOWA

Occupational Medicine Clinic
Department of Internal Medicine
University of Iowa, C-33-GH
T 304, GH
Iowa City, IA 52242
(319) 356-8269

KENTUCKY

Occupational and Preventive
 Medicine
Kentucky Clinic, Room 144
University of Kentucky
Lexington, KY 40536
(606) 257-5166

LOUISIANA

Ochsner Center for Occupational
 Health
3rd floor, Brent House
1514 Jefferson Highway
New Orleans, LA 70121
(504) 838-3955

MARYLAND

Johns Hopkins Center for
 Occupational and
 Environmental Health
Bayview Medical Center
5501 Hopkins Bayview Circle
Baltimore, MD 21224
(410) 550-2322

Occupational Health Project
Maryland University
School of Medicine
405 West Redwood Street
Baltimore, MD 21201
(410) 706-7464

MASSACHUSETTS

Occupational Medicine Clinic
Massachusetts General Hospital
32 Fruit Street
Boston, MA 02114
(617) 726-2721

Center for Occupational and
 Environmental Medicine
Massachusetts Respiratory
 Hospital
2001 Washington Street
Braintree, MA 02184
(617) 848-2600 x 445

Occupational and Environmental
 Health Center
Cambridge Hospital
1493 Cambridge Street
Cambridge, MA 02139
(617) 498-1580

Occupational Health Program
Department of Family and
 Community Medicine
University of Massachusetts
 Medical Center
55 Lake Avenue North
Worcester, MA 01655
(508) 856-2734

MICHIGAN

Division of Occupational Health
Wayne State University
4201 St. Antoine, Suite 4J
Detroit, MI 48201
(313) 577-1420

Occupational and Environmental
 Health Clinic
Michigan State University
Department of Medicine
B338 Clinical Center
East Lansing, MI 48824-1317

(517) 353-1846

Division of Occupational and
Environmental Medicine
505 South Woodward
Royal Oak, MI 48067
(313) 543-4410

Occupational Health Program
University of Michigan
School of Public Health
1420 Washington Heights
Ann Arbor, MI 48109-2029
(313) 764-2594

Center for Occupational and
Environmental Medicine
22255 Greenfield Road
Suite 440
Southfield, MI 48075
(313) 559-6663

Occupational Health Service
St. Lawrence Hospital
1210 West Saginaw
Lansing, MI 48915
(517) 377-0309

MINNESOTA

Occupational Medicine
Park Nicollet Medical Center
5000 West 39th Street
St. Louis Park, MN 55416
(612) 927-3170

Occupational Health Services
Ramsey Clinic
640 Jackson Street
St Paul, MN 55101
(612) 221-3771

Columbia Park Medical Group
6401 University Ave, NE, #200
Fridley, MN 55432
(612) 571-1005

NEW JERSEY

Environmental and Occupational
Health Clinic
Robert Wood Johnson Medical
School
681 Frelinghuysen Road
Piscataway, NJ 08855
(908) 932-0123

EnviroCare
135 Raritan Center Pkwy
Edison, NJ 08837
(908) 225-5454

NEW MEXICO

Employee Occupational Health
Services
Family Practice Center, Rm 232
University of New Mexico
2400 Tucker, NE
Albuquerque, NM 87131
(505) 277-7810

NEW YORK

Occupational Health Clinic
Mt. Sinai Hospital
1 Gustave L. Levy Place
New York, NY 10029
(212) 241-9743; 9740

Mt. Sinai Occupational Medical
Clinic—Hudson Valley
Division
Phelps Memorial Hospital
701 North Broadway
North Tarrytown, NY 10591
(914) 366-3670; 3000

Bellevue Hospital
Occupational and Environmental
Health Clinic
First Avenue and 27 St, CD349
New York, NY 10016
(212) 561-4572

Union Occupational Health
 Center
450 Grider Street
Buffalo, NY 14215
(716) 894-9366

Eastern New York Occupational
 Health Program
1202 Troy-Schenectady Road
Latham, NY 12110
(518) 783-1518

Finger Lakes Regional
 Occupational Health Program
University of Rochester
435 E. Henrietta Road, #4F-12
Rochester, NY 14620
(716) 274-7105

Occupational Medicine, HFC,
 Level 3
SUNY School of Medicine
Stony Brook, NY 11794-8036
(516) 444-2167

Central New York Occupational
 Health Clinical Center
550 Harrison Center, Suite 300
Syracuse, NY 13202
(315) 464-6422

Family Practice Residency
 Program
Utica Satellite Center
St. Elizabeth Hospital
Foery Drive
Utica, NY 13501
(315) 798-1149

NORTH CAROLINA

Division of Occupational and
 Environmental Medicine
Duke Medical Center, Box 2914
Durham, NC 27710
(919) 286-3232

OHIO

Cleveland Clinic Foundation
Section of Occupational Health
 and Medicine
1 Clinic Center
9500 Euclid Avenue
Cleveland, OH 44195
(216) 444-5707,
(800) 223-2273

Greater Cincinnati Occupational
 Health Center
10475 Reading Rd, Suite 405
Cincinnati, OH 45241
(513) 769-0561

Center for Occupational Health
Holmes Hospital
Eden and Bethesda Ave, 1st Fl,
Tate Wing ML458
Cincinnati, OH 45267-0458
(513) 558-1234

Occupational Health Center,
University Hospitals of Cleveland
Douglas J. Morp Health Center
2074 Abingdon Road
Cleveland, OH 44106
(216) 844-1619

Occupational and Environmental
 Health Clinic
Department of Family Practice
MetroHealth Medical Center
2500 Metro-Health Drive
Cleveland, OH 44109
(216) 398-5494

OKLAHOMA

University Occupational Health
 Services
1600 North Phillips
Oklahoma City, OK 73104
(405) 271-3100

OREGON

Legacy Occupational Medical
 Clinic
1650 NW Front, Suite 180
Portland, OR 97209
(503) 226-6744

PENNSYLVANIA

Department of Community and
Preventive Medicine
Division Occupational and
 Environmental Health
Medical College of Pennsylvania
3300 Henry Avenue
Philadelphia, PA 19129
(215) 842-6540

Occupational and Environmental
 Medicine Clinic
149 Lothrop Hall
190 Lothrop St.
Pittsburgh, PA 15261
(412) 648-3240

Occupational and Environmental
 Medicine Program
University of Pittsburgh
GSPH Room A-718
130 DeSoto Street
Pittsburgh, PA 15261
(412) 624-9985

RHODE ISLAND

Memorial Hospital of Rhode
 Island
Occupational Health Service
Brown University Program in
 Occupational Medicine
Division of General Internal
 Medicine
111 Brewster Street
Pawtucket, RI 02860
(401) 729-2000

UTAH

Occupational Medicine Clinic
Rocky Mountain Center for
 Occupational and
 Environmental Health,
Bldg 512, Utah University
Salt Lake City, UT 84112
(801) 581-4800

WorkMed - Occupational Health
 Clinic
1685 West 2200 South
Salt Lake City, UT 84119
(801) 972-8850

VIRGINIA

University Internal Medicine
 Foundation
Medical Clinic
 Environmental Medical
 College of Virginia
Box 520, MCV Station
Richmond, VA 23298
(804) 786-9059

WASHINGTON

Occupational Medicine Clinic -
 Harborview
Medical Center, University of
 Washington
325 9th Avenue, ZA-66
Seattle, WA 98104
(206) 223-3005

WEST VIRGINIA

Division of Occupational and
 Environmental Health
Department of Family and
 Community Health,
Marshall University Medicine
 School
1801 Sixth Avenue

Huntington, WV 25755
(304) 696-7041

WISCONSIN

OMCA
16351 West Lincoln Avenue
New Berlin, WI 53151
(414) 786-4422

Medical Group/West Allis
9131 West Greenfield Ave
West Allis, WI 53214
(414) 774-8500

CANADIAN OCCUPATIONAL
 HEALTH CLINICS

ALBERTA

Alberta Workers Health Center
111-10451 170 Street
Edmonton, Alberta T5P 4T2
(403) 486-9009

MANITOBA

Manitoba Federation of Labour
Occupational Health Center
102-275 Bway
Winnipeg, Manitoba R3C 4M6
(204) 949-0811

ONTARIO

McMaster University
Occupational Health Program
1200 Main St West, Room 3H50
Hamilton, Ontario L8N 3Z5
(416) 525-9140, ext 2333

Sandy Hill Health Centre
24 Selkirk
Venier, Ontario K1L 6N2
(613) 741-7752

Evans Occupational Health Clinic
364 Evans Avenue
Toronto, Ontario M8Z 1K5
(416) 252-5885

Lakeshore Area Multi-Services
Project on Occupational Health
185 5th Street
Toronto, Ontario M8V 2Z5
(416) 252-6471

Occupational and Environmental
 Health Clinic
St. Michael's Hospital
61 Queen St East, 8th Fl
Toronto, Ontario M5C 2T2
(416) 867-7470

QUEBEC

Direction de la Sante Publique
1075 Chemin Suite-Soy
Quebec, G1S 2M1
(418) 643-6084

APPENDIX 2
Safety Supply Sources - 1993

The following lists large full-line distributors of safety equipment.

Birmingham, AL
Wyatt Safety Supply Co Inc
(205) 942-0050

Hayward, CA
Safety Supply America
(510) 784-0104

Los Angeles, CA
Safety Supply America
(213) 603-8788

New Haven, CT
Connecticut Safety Supply
(203) 932-3641

Tampa, FL
Safety Equipment Company
(813) 621-4921

Atlanta, GA
Safety Supply America
(404) 355-6323

Indianapolis, IN
ORR Safety Equipment
 Company
(317) 248-8331

Kansas City, KS
Day Star Corporation
(816) 221-1401

Baltimore, MD
Maryland First Aid
(301) 561-1820

Detroit, MI
Argus Supply Company
(313) 774-8900

St Louis, MO
Wise El Santo Company
(314) 428-3100

Hackensack, NJ
Olympic Glove Company
(800) 526-0122

New York, NY
Eastco Industrial Safety Corp
(800) 221-0224

Uniondale, NY
Global Safety
(516) 794-1234

Cincinnati, OH
ORR Safety Supply Company
(513) 489-0800

Akron, OH
Twyman-Templeton Company
(216) 929-3388

Portland, OR
Sanderson Safety Supply Co
(503) 238-5700

Philadelphia, PA
Industrial Products Company
(215) 547-4400

Philadelphia, PA
Arbill Industries
(215) 228-4011

Pittsburgh, PA
Safety First Supply
(412) 787-8600

Grand Prairie, TX
Dantack Corporation
(214) 988-8200

Houston, TX
Vallen Safety Supply Company
(713) 462-8700

Seattle, WA
Rice Safety Supply
(206) 767-4500

Madison, WI
Lab Safety Supply Company
(608) 754-2345
(800) 356-0783

Milwaukee, WI
Lyons Safety
(414) 255-7300

Canada
Safety Supply Canada
Richmond Hills, Toronto
(416) 222-4111
25 branches throughout Canada.

BIBLIOGRAPHY

ART HAZARDS REFERENCES
*Articles and books marked with a * are available from the Center for Safety in the Arts. Most of the articles listed here are in CSA's library, which is available for research.*

1. Agoston, G. (1969). Health and safety hazards of art materials. *Leonardo* 2, 373.
2. Alexander, W. (1973/74). Ceramic toxicology. *Studio Potter* Winter, 35.
3. American Art Clay Co., Inc. (1987). *Ceramics Art Material Safety in the Classroom and Studio.* AMACO, Indianapolis, IN.
4. Arts, Crafts and Theater Safety. Acts Facts. newsletter.
5. ASTM Subcommittee D01.57 on Artist Paints and Related Materials. (1984). *ASTM D4236. Standard Practice for Labeling Art Materials for Chronic Health Problems.* American Society for Testing and Materials, Philadelphia, PA.
6. Ayers, G., and Zaczkowski, J. (1991). *Photo Developments—A Guide to Handling Photographic Chemicals.* Envision Compliance Ltd., Bramalea, Ont., Canada.
7. Babin, A. and McCann, M. (1992). *Waste Management and Disposal for Artists and Schools.* Center for Safety in the Arts, New York, NY.
8. Bailey, J. R. (1977). What evil lurks? *Photomethods Magazine.* 20(2), 51.
9. Ballesteros, M., Zuniga, C. M. A., Cardenas, O. A. (1983). Lead concentrations in the blood of children from pottery-making families exposed to lead salts in a Mexican village. *Bull. Pan. Am. Health Org.* 17(1), 35–41.
10. Barazani, G. (1979). *Ceramic Health Hazards,* Hazards in the Arts, Chicago, IL.
11. Barazani, G. (1980). Glassblowing hazards. *Glass Studio* #11, 34.
12. Barazani, G. (1980). Hazards of stained glass. *Glass Studio* #10, 33.
13. Barazani, G. (Ed.). (1977). *Health Hazards in Art Newsletter* I & II. Hazards in Art, Chicago, IL.

14. **Barazani, G. (1974 to date).** Protecting your health, column. *Working Craftsman* (now in *The Crafts Report*).
15. **Barazani, G. (1978).** *Safe Practices in the Arts and Crafts: A Studio Guide.* College Art Association, New York.
16. **Baxter, P.J., Samuel, A.M., and Holkham, M.P.E. (1985).** Lead hazards in British stained glass workers. *Br. J. Ind. Med.* 291, 6492.
17. **Berendosohn, R. (1987).** Clearing the air. *Fine Woodworking* Nov/Dec, 70–75.
18. **Bond, J. (1976).** Occupational hazards of stained glass workers. *Glass Art* 4(1), 45.
19. **Braun, S., and Tsiatis, A. (1979).** Pulmonary abnormalities in art glassblowers. *J. Occup. Med.* 21(7), 487–489.
20. **Buie, S.E., Pratt, D.S., and May, J.J. (1986).** Diffuse pulmonary injury following paint remover exposure. *Am. J. M.* Ed. 81(4), 702–704.
21. **Canadian Centre for Occupational Health and Safety. (1988).** Infograms on Hand Tools. 16 pp. CCOHS, Hamilton, Ont., Canada.*
22. **Canadian Centre for Occupational Health and Safety. (1988).** Infograms on Powered Hand Tools. 11 pp. CCOHS, Hamilton, Ont., Canada. *
23. **Canadian Centre for Occupational Health and Safety. (1988).** Infograms on Woodworking Machines. 10 pp. CCOHS, Hamilton, Ont., Canada. *
24. **Canadian Centre for Occupational Health and Safety. (1988).** Infograms on Welding. 17 pp. CCOHS, Hamilton, Ont., Canada. *
25. **Carnow, B. (1975).** *Health Hazards in the Arts and Crafts.* Hazards in the Arts, Chicago, IL.
26. **Carnow, B. (1976).** Health hazards in the arts. *Amer. Lung Assoc. Bull.,* January/February, 2–7. *
27. **Center for Safety in the Arts. (1978 to date).** *Art Hazards News.*
28. **Challis, T., and Roberts, G. (1984).** *Caution: A Guide to Safe Practice in the Arts and Crafts.* Sunderland Polytechnic Faculty of Art and Design, England.
29. **Clark, N., Cutter, T., and McGrane, J. (1984).** *Ventilation.* Lyons & Burford, Publishers, New York, NY. *
30. **Clement, J.D. (1976).** *An Assessment of Chemical and Physical Hazards in Commercial Photographic Processing.* M.S. thesis, University of Cincinnati, Cincinnati, OH.
31. **Curry, S., Gerkin, P., Vance, M., and Kimkel, D. (1987).** Ingestion of lead-based ceramic glazes in nursing home residents. Presented at annual meeting American Assoc. of Poison Control Centers, Vancouver, BC, Canada.

32. **Department of National Health and Welfare, Canada. (1988).** The Safer Arts: the Health Hazards of Arts and Crafts Materials. (10 Posters) Department of Supply and Services Catalogue Number H42–2/10–1988E, Ottawa, Ont., Canada.

33. **Dreggson, A. (1977).** Lead poisoning. *Glass* 5(2), 13.

34. **Driscoll, R.J., Mulligan, W.J., Schultz, D., and Candelaria, A. (1988).** Malignant mesothelioma: a cluster in a native American population. *New Engl. J. Med.* 318, 1437–1438.

35. **Eastman Kodak Co. (1977).** *Safe Handling of Photographic Chemicals.* Eastman Kodak, Rochester, NY.

36. **Eastman Kodak Co. (1987).** General guidelines for ventilating photographic processing areas, CIS-58. Eastman Kodak, Rochester, NY.

37. **Feldman, R., and Sedman, T. (1975).** Hobbyists working with lead. *New Engl. J. Med.* 292, 929.

38. **Fink, T. J. (1990).** Chemical hazards of woodworking. *Fine Woodworking.* Jan/Feb, 58–63.

39. **Firenze, R. B., and Walters, J.B. (1981).** *Safety and Health for Industrial/Vocational Education for Supervisors and Instructors.* National Institute for Occupational Safety and Health/Occupational Safety and Health Administration, Washington, DC.

40. **Food and Drug Administration. (1991).** Getting the lead out. *FDA Consumer* July-August, 1991, 26–31.

41. **Foote, R. (1977).** Health hazards to commercial artists. *Job Safety and Health* November, 7.

42. **Freeman, V., and Humble, C.G. (1989).** Prevalence of illness and chemical exposures in professional photographers. Presented at the 1989 Annual Meeting of the American Public Health Association, Boston, MA.

43. **Goh, C. (1988).** Occupational dermatitis from gold plating. *Contact Dermatitis.* 18 (2), 122–123.

44. **Graham, J., Maxton, D., and Twort, C. (1981).** Painter's palsy: a difficult case of lead poisoning. *Lancet* November 21, 1159.

45. **Hall, A.H., and Rumack, B.H. (1990).** Methylene chloride exposure in furniture stripping shops: ventilation and respirator use practices. *J. Occup. Med.* 32(1), 33–37.

46. **Halpern, F., and McCann, M. (1976).** Health hazards report: caution with dyes. *Craft Horizons* August, 46–49.

47. **Handley, M. (1988).** *Photography and Your Health.* Hazard Evaluation System and Information Service, California Department of Health Services, Berkeley, CA.

48. **Hedeboe, J., Moller, L. F., Lucht, U., and Christensen, S.T. (1982).** Heat generation in plaster-of-paris and resulting hand burns. Burns 9(1), 46–48.

49. Helper, E., Napier, N., Hillman, M., and Gatz, R. (1979). *Final Report on Product/Industry Profile on Art Materials and Selected Craft Materials* (3 parts). Battelle, Columbus, OH.

50. Hodgson, M., and Parkinson, D. (1986). Respiratory disease in a photographer. *Am. J. Ind. Med.* 9 (4), 349–354.

51. Houk, C., and Hart, C. (1987). Hazards in a photography lab; a cyanide incident case study. *J. Chem. Educ.* 64 (10), A234-A236.

52. Hughes, R., and Rowe, M. (1982). *The Coloring, Bronzing, and Patination of Metals.* Craftscouncil, London, England.

53. Johnson, L. M., and Stinnett, H. (1991). *Water-Based Inks: A Screenprinting Manual for Studio and Classroom.* 2nd ed. Philadelphia Colleges of the Arts Printing Workshop, Philadelphia, PA. *

54. Jenkins, C. L. (1978). Textile dyes are potential hazards. *J. Environ. Health* 40(5), 279–284. *

55. Kern, D.G., and Frumkin. H. (1988). Asbestos-related disease in the jewelry industry: Report of two cases. *Amer. J. Ind. Med.* 13, 407–410.

56. Kipen, H., and Lerman, Y. (1986). Respiratory abnormalities among photographic developers: a report of three cases. *Am. J. Ind. Med.* 9(4), 341–347.

57. Lampe, K., and McAnn, M. (1985). *AMA Handbook of Poisonous and Injurious Plants,* American Medical Association, Chicago, IL.

58. Lead Industries Association. (1972). *Facts About Lead Glazes for Artists, Potters and Hobbyists.* Lead Industries Assoc., New York, NY.

59. Letts, N. (1991). Artist dies in basement cyanide accident. *Art Hazards News* 14(1), 1.

60. Liden, C. (1984). Occupational dermatoses in a film laboratory. *Contact Dermatitis* 10(2), 77–87.

61. Lydahl, E., and Pjhilipson, B. (1984). Infrared radiation and cataract. II. Epidemiological investigation of glass workers. *Acta Ophthalmol.* 62(6), 976–992.

62. Mallary, R. (1983). The air of art is poisoned. *Art News* October, 34.

63. McCann, M. (1974–78). Art hazards news column. *Art Workers News.* New York, NY.

64. McCann, M. (1992). *Art Safety Procedures: A Health and Safety Manual for Art Schools and Art Departments.* Center for Safety in the Arts, New York, NY.

65. McCann, M. (1992). *Artist Beware.* 2nd ed., Lyons & Burford, Publishers, New York, NY.

66. McCann, M. (1992). Emergency response to spills and leaks. Center for Safety in the Arts, New York, NY.

67. McCann, M. (1975). Health hazards in printmaking. *Print Review* 34, 20.

68. **McCann, M. (1976).** Health hazards in painting. *American Artist* February, 73.
69. **McCann, M. (1978).** The impact of hazards in art on female workers. *Preventive Medicine* 7, 338–348. *
70. **McCann, M. (1992).** Occupational and environmental hazards in art. *Env. Res.* 59, 139–144.
71. **McCann, M. (1992).** Occupational hazards in the arts, in *Environmental and Occupational Medicine.* 2nd ed., Little, Brown and Company, Boston, MA.
72. **McCann, M., and Barazani, G. (Eds.) (1980).** *Health Hazards in the Arts and Crafts. Proceedings of the SOEH Conference on Health Hazards in the Arts and Crafts.* Society for Occupational and Environmental Health, Washington, DC. *
73. **McGrane, J. (1986).** *Reproductive Hazards in the Arts and Crafts.* Center for Safety in the Arts, New York, NY. *
74. **Miller, A.B., and Blair, A. (1983).** Mortality patterns among press photographers (letter). *J. Occup. Med.* 25, 439–440.
75. **Miller, A.B., Blair, A., and McCann, M. (1985).** Mortality patterns among professional artists: A preliminary report. *J. Environ. Path. Toxicol. Oncol.* 6, 303–313.
76. **Miller, A.B., Silverman, D.T., Hoover, R.N., and Blair, A. (1986).** Cancer risk among artistic painters. *Am. J. Ind. Med.* 9, 281–287.
77. **MMWR. (1982).** Chromium sensitization in an artist's workshop. *Mortality and Morbidity Weekly Reports* 31, 111.
78. **Moses, C., Purdham, J., Bowhay, D., and Hoslin, R. (1978).** *Health and Safety in Printmaking.* Occupational Hygiene Branch, Alberta Labor, Edmonton, Alberta, Canada.
79. **National Institute for Occupational Safety and Health. (1983).** *Preventing Health Hazards from Exposure to Benzidine-Congener Dyes.* DHHS (NIOSH) Publication #83–105. NIOSH, Cincinnati, OH.
80. **Ng, T.P., Allen, W.G.L., Tsin, T.W., and O'Kelly, F.J. (1985).** Silicosis in jade workers. *Amer. Rev. Resp. Dis.* 42(11), 761–764.
81. **Nixon, W. (1980).** Safe handling of frosting and etching solutions. *Stained Glass* Fall, 215.
82. **Ontario Crafts Council. (1980).** *Crafts and Hazards to Health* (bibliography). Ontario Crafts Council, Toronto, Canada. *
83. **Ontario Lung Association. (1982).** *Health Hazards in Arts and Crafts.* American Lung Association, New York, NY.
84. **Edward Orton Jr. Ceramic Foundation. (1990).** *Kiln Safety.* Edward Orton Jr. Ceramic Foundation, Westerville, OH.

85. **Polato, R., Morossi, G., Furlan, I., and Moro, G. (1989).** Risk of abnormal lead absorption in glass decoration workers. *Med. Lav.* 80(2), 136–139.

86. **Prockup, L. (1978).** Neuropathy in an artist. *Hospital Practice* November, 89.

87. **Quinn, M., Smith, S., Stock, L., and Young, J. (Eds.) (1980).** *What You Should Know About Health and Safety in the Jewelry Industry.* Jewelry Workers Health and Safety Research Group, Providence, RI.

88. **Ramazzini, B. (1940).** *De Morbis Artificum (Diseases of Workers).* 2nd ed. (1713). Translated by W. C. Wright, University of Chicago Press, Chicago, IL.

89. **Rickard, T., and Angus, R. (1983).** *A Personal Risk Assessment for Craftsmen and Artists.* Ontario Crafts Council/College, University and School Safety Council of Ontario, Toronto, Canada. *

90. **Rossol, M. (1980–82).** Ceramics and Health. Compilation of articles from *Ceramic Scope.*

91. **Rossol, M. (1990).** *The Artist's Complete Health and Safety Guide.* Allworth Press, New York, NY.

92. **Rossol, M. (1991).** *Professional Stained Glass Safety Training Manual: Our Right-To-Know Program.* The Edge Publishing Group, Inc., Brewster, MA.

93. **Seeger, N. (1984).** *Alternatives for the Artist.* Revised editions, School of the Art Institute of Chicago, Chicago, IL.
 An Introductory Guide to the Safe Use of Materials.
 A Printmaker's Guide to the Safe Use of Materials.
 A Photographer's Guide to the Safe Use of Materials.
 A Painter's Guide to the Safe Use of Materials.
 A Ceramist's Guide to the Safe Use of Materials.

94. **Shaw, S. (1985).** In process: reproductive hazards in photography. *Photomethods* 28(6).

95. **Shaw, S., and Rossol, M. (1991).** *Overexposure: Health Hazards in Photography,* 2nd ed. Allworth Press, New York, NY. *

96. **Shaw, S., and Rossol, M. (1989).** Warning: Photography May Be Hazardous to Your Health. *ASMP Bulletin* 8(6). entire issue.

97. **Siedlicki, J. (1968).** Occupational health hazards of painters and sculptors. *J. Am. Med. Assoc.* 204, 1176.

98. **Siedlicki, J. (1972).** Potential hazards of plastics used in sculpture. *Art Education* February, 78.

99. **Siedlicki, J. (1975).** *The Silent Enemy.* 2nd ed. Artists' Equity Association, Washington, DC.

100. **Spandorfer, M., Curtiss, D., and Snyder, J. (1992).** *Making Art Safely.* Van Nostrand Reinhold, New York, NY.*

101. **Stewart, R., and Hake, C. (1976).** Paint-remover hazard. *J. Am. Med. Assoc.* 235, 398.
102. **Stopford, W. (1988).** Safety of lead-containing hobby glazes. *North Carolina Med. J.* 49(1), 31–34.
103. **Swaen, G.M.H., Passier, P.E.C.A., and Van Attekum, A.M.N.G. (1988).** Prevalence of silicosis in the Dutch fine-ceramic industry. *Int. Arch. Occup. Environ. Health* 60(1), 71–74.
104. **Tell, J. (Ed.) (1988).** *Making Darkrooms Saferooms.* National Press Photographers Association, Durham, NC.
105. **Waller, J. (1980).** Another aspect of health issues in ceramics. *Studio Potter* 8(2), 60.
106. **Waller, Julian (ed.) (1987).** Health and the Potter. *Studio Potter* entire June issue.
107. **Waller, J.A., Payne, S.R., and Skelly, J.M. (1989).** Injuries to carpenters. *J. Occup. Med.* 31 (8), 687–692.
108. **Waller, J., and Whitehead, L. (1977–79).** Health issues (regular column). *Craft Horizons.*
109. **Waller, J., and Whitehead, L. (Eds.). (1977).** *Health Hazards in the Arts—Proceedings of the 1977 Vermont Workshops.* University of Vermont Department of Epidemiology and Environmental Health, Burlington, VT.
110. **Weiss, L. (1987).** *Health Hazards in the Field of Metalsmithing.* Society of North American Goldsmiths Education and Research Department.
111. **Wellborn, S. (1977).** Health hazards in woodworking. *Fine Woodworking* Winter, 54–57.
112. **White, N.W., Chetty, R., Bateman, E. (1991).** Silicosis among gemstone workers in South Africa. *Am. J. Ind. Med.* 19, 205–213.
113. **Wills, J.H. (1982).** Nasal cancer in woodworkers: A review. *J. Occup. Med.* 24(7), 526–530.
114. **Woods, B., and Calnan, C.D. (1976).** Toxic woods. *Br. J. Derm.* 9513, 1–97.

CHILDREN'S ART HAZARDS REFERENCES

1. **Babin, A., Peltz, P., and Rossol, M.** (1989). Children's art supplies can be toxic. revised. Center for Safety in the Arts, New York, NY.
2. **California State Department of Health Services. (1988).** *Art and Craft Materials Acceptable for Kindergarten and Grades 1–6.* 2nd edition. Sacramento, CA. (out of print)
3. **California Public Interest Research Group. (1984).** *Not a Pretty Picture: Art Hazards in the California Public Schools.* CALPIRG, Sacramento, CA.

4. Jacobsen, L. (1984). *Children's Art Hazards.* Natural Resources Defense Council, New York, NY.
5. Kawai, M., Torimumi, H., Katagiri, Y., and Maruyama, Y. (1983). Home lead-work as a potential source of lead exposure for children. *Arch. Occ. Environ. Health* 53(1), 37–46.
6. Massachusetts Public Interest Research Group. (1983). *Poison Palettes: A Study of Toxic Art Supplies in Massachusetts Schools.* MASSPIRG, Boston, MA.
7. McCann, M. (1986). Health and safety for secondary school arts and industrial arts. Center for Safety in the Arts, New York, NY.
8. McCann, M. (1988). Teaching art safely to the disabled. Center for Safety in the Arts, New York, NY.
9. New York Public Interest Research Group. (1982). *Children Beware—Art Supplies in the Classroom.* NYPIRG, New York, NY.
10. Oregon State Public Interest Research Group. (1985). *Toxics in Art Supplies - Hazardous Hobbies.* Oregon PIRG, Portland, OR.
11. Peltz, P. (1984). Day care centers using toxic art materials. *Art Hazards News* March, 1.
12. Qualley, C. (1986). *Safety In the Art Room.* Davis Publications, Worcester, MA.
13. Schultz, L. (Ed.). (1982). *Art Safety Guidelines K–12.* National Art Education Association, Reston, VA.
14. U.S. Public Interest Research Group. (1986). *Not a Pretty Picture: Toxics in Art Supplies in Washington, DC Area Public Schools.* USPIRG, Washington, DC.
15. U.S. Public Interest Research Group. (1987). *The Picture Looks Brighter: Improvements in Artroom Safety in Washington, DC Area Public Schools.* USPIRG, Washington, DC.

GENERAL REFERENCES

1. Accrocco, J.O. (1988). *The MSDS Pocket Dictionary.* rev. Genium Publishing Company, Schenectady, NY.
2. A. M. Best Company. *Best's Safety Directory.* 2 Volumes. A.M. Best, Oldwick, NJ. (Updated regularly.)
3. American Conference of Governmental Industrial Hygienists. (1986). *Documentation of the Threshold Limit Values for Substances in Workroom Air.* 5th ed. ACGIH, Cincinnati, OH.
4. American Conference of Governmental Industrial Hygienists. (1990). *Threshold Limit Values for Chemical Substances and Physical Agents in the Workroom Environment.* ACGIH, Cincinnati, OH.
5. American National Standards Institute. (1990). *American National Standard for Emergency Eyewash and Shower Equipment* (ANSI Z358.1–1990). ANSI, New York, NY.

6. **American National Standards Institute. (1971).** *Fundamentals Governing the Design and Operation of Local Exhaust Systems.* ANSI Z9.2–1971. ANSI, New York, NY.

7. **American National Standards Institute. (1989).** *American National Standard Practice for Occupational and Educational Eye and Face Protection* (ANSI Z87.1–1989). ANSI, New York, NY.

8. **American National Standards Institute. (1980).** *American National Standard Practices for Respiratory Protection.* ANSI Z88.2–1980. ANSI, New York, NY.

9. **American National Standards Institute. (1983).** *Safety in Welding and Cutting* (ANSI Z49.1–1983). ANSI, New York, NY.

10. **Committee on Industrial Ventilation. (1988).** *Industrial Ventilation: A Manual of Practice.* 20th ed., American Conference of Governmental Industrial Hygienists, East Lansing, MI. (Updated regularly).

11. **Environmental Protection Agency.** *40 CFR 260 to 267. Hazardous Waste Management Regulations.* Government Printing Office, Washington, DC.

12. **Gosselin, R., Smith, R., and Hodge, H. (1987).** *Clinical Toxicology of Commercial Products.* 6th ed., Williams and Wilkins, Baltimore, MD.

13. **Hawley, G. (Ed.) (1987).** *The Condensed Chemical Dictionary.* 11th ed. Van Nostrand Reinhold, New York, NY.

14. **Industrial Hygiene Subcommittee, Alliance of American Insurers. (1986).** *Handbook of Organic Industrial Solvents.* 6th ed. Alliance of American Insurers, Chicago, IL.

15. **International Labor Office. (1983).** *Encyclopedia of Occupational Health and Safety.* 2 volumes. 3rd ed. Geneva, Switzerland.

16. **Klaasen, C. D., Ambdur, M. O., and Doull, J., eds. (1986).** *Casarett and Doull's Toxicology.* 3rd ed., MacMillan Publishing Co., Inc., New York, NY.

17. **Lewis, R. (1991).** *Carcinogenically Active Chemicals: A Reference Guide.* Van Nostrand Reinhold, New York, NY.

18. **National Fire Protection Association. (1988).** *NFPA #10. Portable Fire Extinguishers.* NFPA, Boston, MA.

19. **National Fire Protection Association. (1987).** *NFPA #30. Flammable and Combustible Liquids Code.* NFPA, Boston, MA.

20. **National Fire Protection Association. (1986).** *NFPA #45. Fire Protection for Laboratories Using Chemicals.* NFPA, Boston, MA.

21. **National Fire Protection Association. (1974).** *NFPA #58. Storage and Handling of Liquefied Petroleum Gases.* NFPA, Boston, MA.

22. **National Fire Protection Association. (1987).** *NFPA #70. National Electrical Code.* NFPA, Boston, MA.

23. **National Institute of Occupational Safety and Health. (1976).** *A Guide to Industrial Respiratory Protection.* DHEW (NIOSH) #76–189. Government Printing Office, Washington, DC.

24. **National Institute of Occupational Safety and Health.** *Criteria for Recommended Standards: Occupational Exposure To* [various chemicals]. Government Printing Office, Washington, D.C.

25. **National Institute of Occupational Safety and Health. (1977).** *Occupational Diseases: A Guide to Their Recognition,* revised ed., Government Printing Office, Washington, DC.

26. **National Institute of Occupational Safety and Health. (1988).** *NIOSH Certified Equipment List as of October 1, 1987.* DHEW (NIOSH) #88–107. Government Printing Office, Washington, DC.

27. **National Institute for Occupational Safety and Health. (1973).** *The Industrial Environment: Its Evaluation and Control.* Government Printing Office, Washington, DC.

28. **National Institute for Occupational Safety and Health. (1986).** *Working in Hot Environments,* DHHS (NIOSH) Publication #86–112. NIOSH, Cincinnati, OH.

29. **New Jersey Right To Know Program.** NJ Hazardous Substance Fact Sheets on [various chemicals]. New Jersey State Department of Health, Trenton, NJ.

30. **Occupational Safety and Health Administration. (1988).** *Occupational Safety and Health Standards for General Industry. 29 CFR 1910.* Government Printing Office, Washington, DC.

31. **Patty, Frank (Ed.) (1982).** *Industrial Hygiene and Toxicology. Vol. II,* 3 parts. 3rd ed., Interscience Publishers, New York, NY.

32. **Pinsky, M. (1987).** *The VDT Book—A Computer User's Guide to Health and Safety.* New York Committee for Occupational Safety and Health, New York, NY.

33. **Stellman, J. and Daum, S. (1973).** *Work Is Dangerous to Your Health.* Vintage, New York, NY.

34. **U.S. Congress, Office of Technology Assessment. (1985).** *Reproductive Health Hazards in the Workplace.* OTA-BA-266. U.S. Government Printing Office, Washington, DC.